BARROW-IN-FURNESS AT WORK

PEOPLE AND INDUSTRIES THROUGH THE YEARS

GILL JEPSON

AMBERLEY

ACKNOWLEDGEMENTS

I would like to acknowledge the people who have assisted me in sourcing photographs and stories to include in this book. Thank you to Susan Benson of Cumbria Archives and the Barrow Public Library, Sabine Skae from the Dock Museum Barrow, Barrow Borough Council, and English Heritage for the use of images and photography. Thanks to Sheila Batty, Susan Howell, Valerie Vicich, Linda McCaffrey, David Dawson, Jennifer Foote, Stella Patience, Harry Jepson, Paul Culley, Kay Parker and Ray Guselli for photographs, and Terry and Nerys Curtis for access to the solar farm.

Every effort has been made to obtain permission for copyright material in this book; however, if any material has been inadvertently used without permission or acknowledgement then I apologise and the publisher will make the necessary correction at the first opportunity.

I would also like to acknowledge the use of the following publications in researching this book:

Antiquities of Furness by Thomas West
Annales Furnessienses by Thomas Beck
Barrow and District by F. Barnes
Voices from Barrow and Furness by Alice Leach
Voices from the Past: Contemporary Accounts of Barrow's History by Bryn Trescathric
Submarines by Commander R. Compton-Hall
Barrow-in-Furness Year Book 1934

First published 2017

Amberley Publishing
The Hill, Stroud
Gloucestershire, GL5 4EP

www.amberley-books.com

Copyright © Gill Jepson, 2017

The right of Gill Jepson to be identified as the Author of this work has been asserted in accordance with the Copyrights, Designs and Patents Act 1988.

ISBN 978 1 4456 7003 4 (print)
ISBN 978 1 4456 7004 1 (ebook)

British Library Cataloguing in Publication Data.
A catalogue record for this book is available from the British Library.

Origination by Amberley Publishing.
Printed in the UK.

CONTENTS

INTRODUCTION

This is my third book about Barrow-in-Furness and probably has the most apt subject: work. Barrow was an insignificant village at the tip of the Furness Peninsula until the early 1840s. The Industrial Revolution arrived quickly and it was the catalyst for a frenzy of work, population growth and development.

In the early nineteenth century the existing industry, iron ore and slate mining, was still being carried out on a small scale. This was until the slate quarries at Kirkby, owned by the Earl of Burlington, grew in the 1820s and the product was shipped by cart to piers at Barrow. Later, the iron speculator Henry William Schneider arrived and very soon rich deposits of haematite were discovered. Investors, including Schneider, the Duke of Devonshire and the Duke of Buccleuch, created the Furness Railway Company and began to transport the slate from Kirkby and iron ore from Lindal to the piers at Barrow. This was then taken by sea to be processed in Wales.

Very quickly the entrepreneurs, now joined by a young railway manager called James Ramsden, saw the sense in processing the iron locally. This was the start of the steelworks, which was a dominant industry in the town for many years. From here other industries, like the docks and shipbuilding, blossomed and the town increased in size. The intention of the town fathers was to build a port to rival Liverpool and although the town grew and industry diversified, this never quite happened – despite a valiant attempt in creating an even bigger dock complex at Cavendish Dock.

By the First World War the natural resources were drying up and the steel industry was flagging. Of course, the shipbuilding industry prospered throughout the Second World War and has survived many difficulties to become one of the leading nuclear submarine builders in the world. The town has adapted and changed and the work options with it. Some new industry has developed, some old industries have survived, but like many post-industrial towns the choice of work fluctuates and can be limited. Service and retail industry has developed and is a significant employer and currently there is a boom in jobs, training and apprenticeships linked to BAE Systems at the shipyard; this is bringing another influx of people to the area to fulfil the employment needs.

The population of Barrow-in-Furness was drawn from a wide-ranging demographic which is still subject to the rise and fall of fortune of the town's main industry. No doubt this cycle will continue for as long as the shipyard exists but this unique town will continue to adhere to its motto *Semper Sursum* – Always Rising.

Gill Jepson, 2017

PRE-INDUSTRIAL BEGINNINGS: AGRICULTURE AND LAND MANAGEMENT

Barrow was originally a very small village. It was situated on a natural harbour and provided access to the Irish Sea. The monks of Furness Abbey owned the village, then known as *Barey*. They were experts at land management and successfully exploited the land and its resources, eventually becoming the second richest abbey after Fountains Abbey in Yorkshire. The monks utilised a system of abbey granges or farmsteads, worked both by the lay brothers from the monastery and the peasants. At the peak of the abbey's power it is estimated that there were up to 250 lay brothers employed to work the land. The quire monks – who were educated and frequently drawn from the wealthier class – administered the lay brothers and the abbey granges. The community was self-sufficient and they were a dominant force in the agricultural and working environment of Furness.

Furness Abbey.

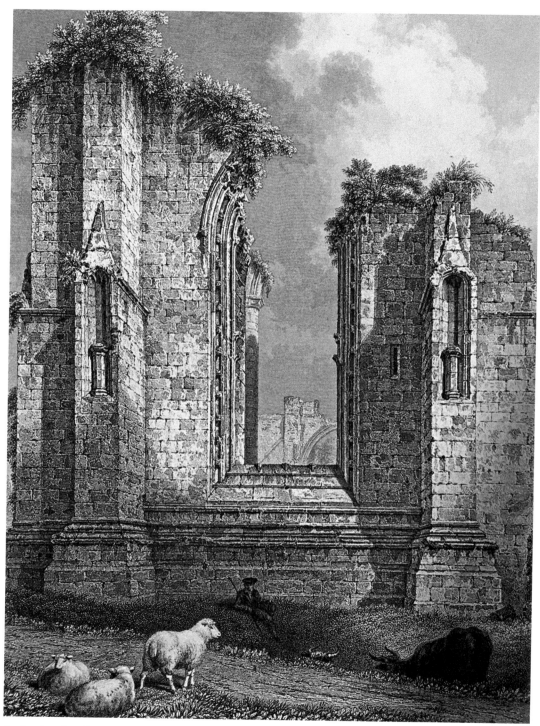

A shepherd at Furness Abbey in the eighteenth century.

Sheep in Abbey Grange pastures.

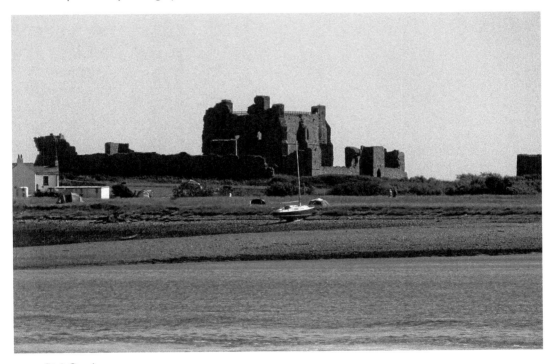

Piel Castle.

The abbot was the Lord of the Manor and operated the feudal system, being paid tithes and rents in kind or boon work. The system was very efficient and provided the abbey with a steady and growing income. Agriculture was the staple occupation in medieval times and Furness was no different to the rest of the country. The monks administered the forests, granges, fisheries and salt pans, and were particularly adept at sheep farming. They held the marshes at Salthouse and used the evaporation method to extract salt. Salt was an important commodity and had commercial value; this could be exported and sold, in addition to wool from the sheep, so farming was extremely important for the monks.

Piel Castle was a natural harbour and in 1212 King John awarded the Abbot of Furness the licence to import wheat, flour and provisions to stave off famine. Twenty years later a full and unlimited licence was given. This was beneficial and increased the opportunity for the abbey to increase their exports and revenues. Piel was useful to monitor traffic coming up the Irish Sea and as a fortified storage depot for the export of wool. Trade was strong and although the monks sometimes clashed with the Crown over their lax attitude to excise duty it became an important asset. As well as being the nominal harbour master, the abbot also had a ship – which was under royal protection – presumably used for the export of goods. One wonders if maybe the monks were the first shipbuilders in the area as well.

The industry of the area was monitored and maintained by the abbey and the fortunes of the people were closely linked to that of the monks. When the Dissolution of the Monasteries took place from 1536 everything changed, and the land and mineral rights were dispersed and sold off. Feudalism ceased and some benefitted from the sale of monastic lands. Over the next few centuries agriculture continued as usual, but now there were different landlords and a little more flexibility.

The colour of the earth in the Furness Peninsula has always been an indicator of its mineral content, particularly iron ore. Its deep red hue is a clear clue that iron is present and the colour bleeds into the River Yarl, giving it the name of Red River. So it is no surprise that mining has been carried on in the area for centuries. Evidence of old workings and remnants left by ancient miners has been found, such as Langdale axes apparently stained with haematite found at the ancient settlement of Urswick. This suggests that iron ore was already being exploited during prehistoric times in Furness. We have more definite evidence of mining during the monastic times. The Cistercians were adept at exploiting the land and profiting from it. There are references in the Coucher Books or Cartulary of the abbey of St Mary of Furness to iron mining and land rights. Apparently, the monks of Furness acquired iron ore from Orgrave, between Dalton and Ireleth. John Stell documented an ongoing dispute between the Abbot of Furness and Hamo of Orgrave over the mining rights in 1235, but the outcome of the dispute is unclear.

In subsequent years the abbey gained a grant of the iron deposits in Dalton, Orgrave and Marton, so this area was traditionally known for its minerals. Mining leases were awarded to William Sandys in 1544 to dig for iron in the Low Furness area. He ran three bloomeries in Furness and wanted to extend his yield and find new sources of iron. Throughout the sixteenth, seventeenth and eighteenth centuries the industry grew and many of the ventures were opencast and the ore processed locally.

Later, as the iron ore yield grew, it was shipped out of the district to be processed. A Customs House was established at Piel in 1720 and the lighthouse at Walney was added in 1790. The first jetty was built in Barrow in 1782 and the export of ore had truly begun.

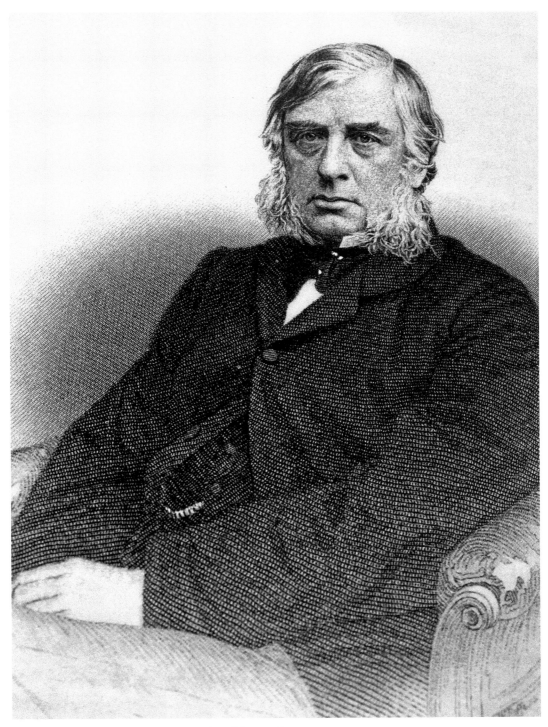

William Cavendish, the 7th Duke of Devonshire.

This early mining heralded the opportunities to come later in the nineteenth century. Mining continued over the intervening years on a small scale, but it required the intervention of Victorian industrialists like H. W. Schneider and investors such as the 7th Duke of Devonshire to realise its full potential.

The abbey itself provided a source of work by both its construction and maintenance and the servicing of the monastery. Quarrying was an important and skilled job. The three quarries from which the abbey stone was sourced are within the same valley and can be seen today. In the west quarry (now wooded), chisel marks and discarded or broken blocks are still visible. Two small carved faces, much weathered, are evidence of masons skill and artistry and peep out from the sandstone cliff. One can even match up the striations of the sedimentary rock with blocks of stone in the abbey buildings.

Masons were employed to build the abbey and the earliest church was Romanesque in style and probably built by French masons. As time passed, English masons would be employed too, often for years at a time. One particularly interesting aspect are the masons' marks which can still be found there. There are hundreds of these marks and they were a unique way for the masons to sign their work and get paid according to what they produced. An especially interesting one is found in the buttery by the door jamb. The same mark can be found at Fountains Abbey in Yorkshire and is a tantalising taste of the people who built the abbey; this journeyman worked in both abbeys and he must have moved about, although sadly we do not know who he was.

Medieval sandstone quarry at Furness Abbey.

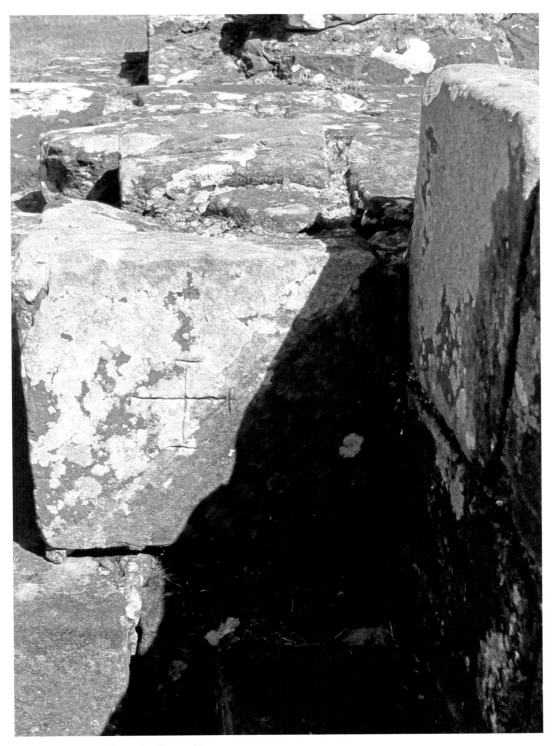

Mason's mark in the Guest House.

Carved face and mason's chisel marks at the quarry face at Furness Abbey.

INDUSTRIAL REVOLUTION: NEW OPPORTUNITIES

There were upwards of forty vessels shipping ore by the eighteenth century and a flurry of jetty building at Barrowhead. These included those constructed by Town and Rawlinson in 1833, Kennedy in 1839 and Schneider in 1842. The railway freight service was begun in 1846 by the Furness Railway Company between Dalton and Kirkby; this later expanded to include Broughton and Ulverston. In 1863 the Furness Railway Company had taken over the Ulverston and Lancaster Railway, linking Barrow to the rest of the north of England. This piece of the industrial jigsaw was vital to the expansion of Barrow and it provided easier and quicker access to the peninsula. After much negotiation and Parliamentary approval

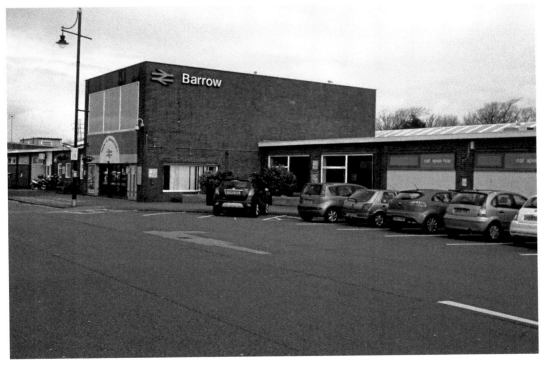

Barrow railway station (the second station on this site).

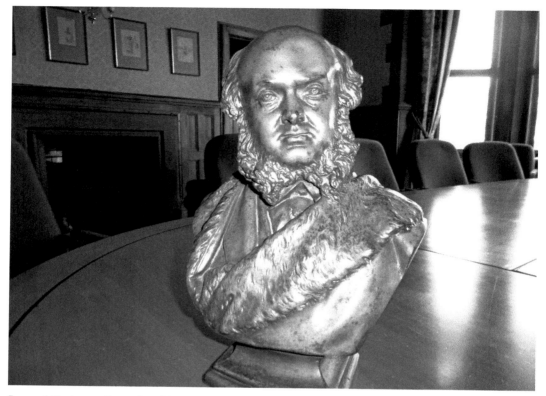

Bust of Sir James Ramsden, Managing Director of the Furness Railway Company, in Barrow Town Hall.

the Furness Railway was fully connected, eradicating the need for dangerous journeys over the 'sands' of Morecambe Bay by horse-drawn carriages.

The iron and mineral trade had grown and James Ramsden, the eventual Managing Director of the Furness Railway, stated in 1850 that '470,000 tons of minerals had been carried over the Furness Railway' since the line opened four years previously. This was in addition to the 78,000 passengers the railway carried. This had a devastating effect on local carriers and carters, who quickly lost their business. The changes also caused a shift in emphasis for the Ulverston Canal and the prevalence of the market town. In time Dalton was reduced in influence too, being subsumed into the growing industrial town of Barrow.

THE RED MEN AND IRON MINING

Iron ore mining was an obvious candidate for growth and development in the nineteenth century. Prospectors had soon realised that the haematite ore in Barrow and Furness was rich and of high quality. H. W. Schneider had introduced his readymade workforce from Cornwall. His tin mines were failing and it made sense to import the miners who already had some expertise. Many of the Cornish found a home at Roose, which became a small community and retained many of its Cornish traditions. The local Mission Church is named after St Perran, the Patron Saint of Cornwall, and at Stonedyke a derelict Methodist chapel can be found.

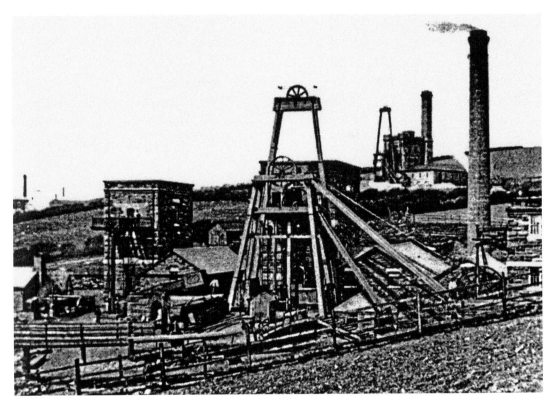

Stank mines.

Roose was close to the Stank mines and a railway line ran through the village to transport the miners to work.

Mining thrived and, for a time, was instrumental in Barrow's development, being the catalyst for other growing industries. Workers flooded into the area in the 1840s and began to change its complexion. The miners could be easily recognised by the red dust covering them; the work was dangerous and took a heavy physical toll, but it was regular employment. The mines gradually declined, finally closing one by one from the start of the twentieth century until the First World War. There is now little physical trace that they ever existed except for the various bumps and depressions in the landscape.

Iron ore mines thrived at Park Mine (Askam) and at Rita and Nigel Pits at Roanhead. These mines were large employers and very important in the early industrial history of the area. There is also evidence of limestone quarrying, with shot holes and lime kilns near to the National Trust depot at Sandscale Haws. In 1852, Myles Kennedy leased the mining rights and the land was exploited until the ore ran out in 1942. It was a lucrative industry and the ore was of high quality.

Roanhead farmhouse was transported from its original site to the present one in 1902 when the deposit was found. The remains of the industrial past are visible but transformed. The pits left from erosion and subsidence are flooded in the same way as those at Park mines. These are managed fish ponds and the whole area is a Site of Special Scientific Interest, some of it managed by the National Trust. The area now supports wildlife, including Natterjack toads, and the farm itself has cattle and sheep; lately diversifying with the odd alpaca.

Yarlside iron ore mines and railway.

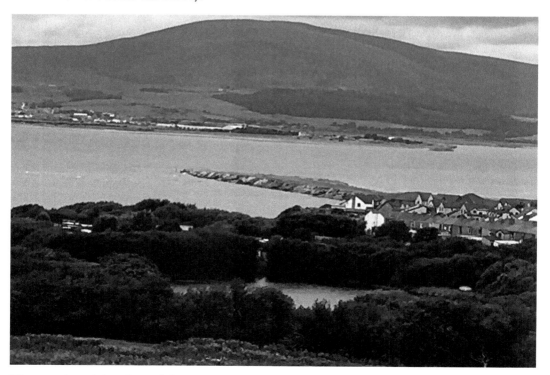

Mine ponds and the pier at Askam.

Nigel Pit – an old iron ore mine at Roanhead.

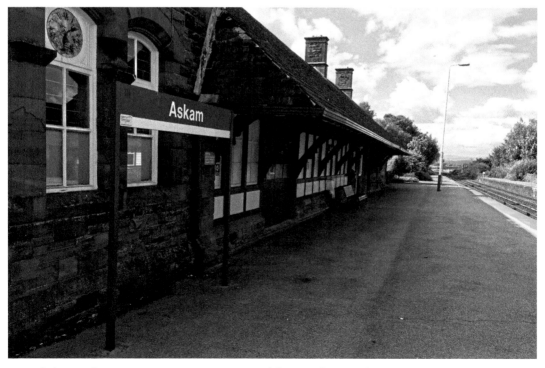

Askam railway station retains many original Furness Railway features.

By the middle of the Victorian era Furness Railway had become fully established. Its lines stretched along the coast, into the tourist areas and connecting with the rest of the country. Trains were ferrying passengers and freight (including shipping materials) back and forth. The Furness Railway was very busy, with staff ensuring the trains ran smoothly and that freight reached its destination, and platforms thronged with passengers making their way to work or travelling for pleasure. The railway was a recognisable brand and its stamp was clear through the design and appearance of its stations and even the cast-iron benches, which are now much sought after with their decorative grapevines, red squirrels and gargoyles. Many of the stations have disappeared or have been compromised: Barrow station was bombed during the war, while Roose was demolished. However, there are still some good examples left, such as the station at Askam-in-Furness. The fabric of the station remains: its red sandstone and half-timbered buildings still present a traditional image of a real railway station.

MEN OF STEEL

When the investors of the iron mines and Furness Railway made the decision to develop their own blast furnaces to process the iron in situ, they prepared the ground for massive change. The processing required skilled workers such as blacksmiths and chain makers, and companies had to seek them outside the town. As with the iron mines, this brought in a new population of workers from other areas. An influx of workers from Dudley and Birmingham arrived, well known for their metal-working skills. Many of them were attracted because of lack of work in their own region and they settled around Hindpool and Ormsgill, in housing provided by the employers and built close to the place of work. Some of these houses still exist. The houses were built from locally quarried sandstone – in the same way those terraces

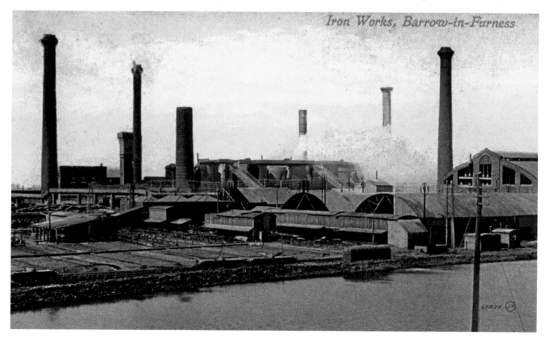

Barrow Iron Works.

at Roose were for the miners. Families put down roots and began their new lives with hope in this emerging new town. Thriving local communities grew around these houses and local amenities such as schools, churches, shops and pubs developed too. The workers and their families lived almost on top of the iron foundries and could see smoke billowing, hear the industrial noises, and witness the creation of a huge slag bank.

William Jesson, a blacksmith striker, arrived in the 1860s from Dudley. In the 1871 census he was living at 34 Buccleuch Street, but by 1881 the family had moved to 8 Lancaster Street and he was a general labourer. One wonders if the family's fortunes had started to fall at this time as there was a slump in Barrow. He emerges again in 1891 living at 4 Bradford Street, which were steel worker's cottages, and he is listed as a chain maker. His parents had joined them in the 1870s (his father was a boot- and shoemaker – a traditional Midlands craft). Both parents had died by 1901 but the family were still residing at Bradford Street, with William listed as a retired chain maker. His son John, an iron work plate layer, and his family were living at Bradford Street too.

Life was hard and the hours were long and arduous. The worker's fortunes rose and fell with those of the steelworks and there were numerous layoffs and short working hours as the industry struggled in the latter part of the nineteenth century. William Jesson and his wife Maria are buried in unmarked public graves at Barrow cemetery, in the shadow of the iron slag banks. The remaining family moved to Rochdale, where there was more reliable work in the mills. Their eldest daughter later worked in munitions during the First World War.

Bradford Street iron workers' cottages.

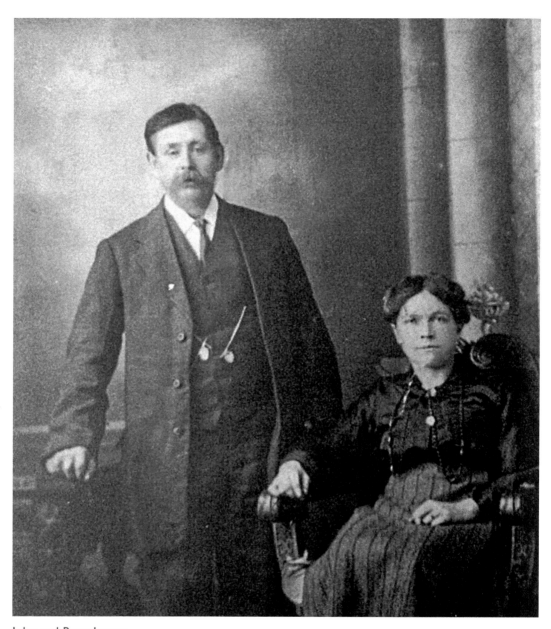

John and Rose Jesson.

THE VICTORIAN AGE: INNOVATION AND GROWTH

Barrow-in-Furness was transformed completely in the early 1840s. A culmination of factors acted as a catalyst for its rapid growth and development. One of these was the entrepreneurialism and optimism of the Victorian mindset. The basic elements were all in place – the iron ore, the railway and the port. Joined with this was a succession of forward thinking and energetic industrialists and investors. People like James Ramsden, H. W. Schneider and the Dukes of Devonshire and Buccleuch ensured success. The transformation was complete with the creation of new industries such as shipbuilding and the Bessemer steel foundries. This hive of industry attracted workers and the population exploded. This in turn forced changes in the town's infrastructure and a massive programme of building had to be undertaken to house the incoming workforce.

As the town grew so projects became more ambitious and the docks were expanded to allow for more exports and imports and the production of bigger ships. To civilise the town, which was principally made up of men, Ramsden introduced the Jute Works to employ women and children. The town was principally a working-class area, but as the century progressed a hierarchy became more apparent. Blue- and white-collar workers moved out to the new suburbs and housing could be classified by social position. The leading lights of the town resided in Gothic mansions on the outskirts of the town, proclaiming their social superiority and wealth. This was mimicked in the cemetery too; the great and the good clustered around the summit of the hill (and Ramsden) while the rest found a resting place according to their own 'degrees'. Barrow grew beyond the confines of the small triangle of buildings it started with. This growth gave rise to other industries and more work for more people, which in turn expanded the town itself. Houses were built along Abbey Road and expanded outwards, creating new suburbs.

Although Barrow was a magnet for those who wanted work, this was not without its own hazards. The indigenous population was overwhelmed if not subsumed by 'off-comers'; it is a well-known fact that very few Barrovians are able to trace their ancestry in the area before 1850. This meant that unfamiliar accents, religious practices and culture were all thrown together in the mix. This amalgamation produced the strange and quite unique 'Barra' accent and introduced pockets of people who were not necessarily keen to mix. Added to this was the constant ebb and flow of seamen arriving and departing on ships and boats, bringing people from many places. There was real bigotry and prejudice to deal

Abbey Road.

Barrow Island tenements, where many of the Irish lived.

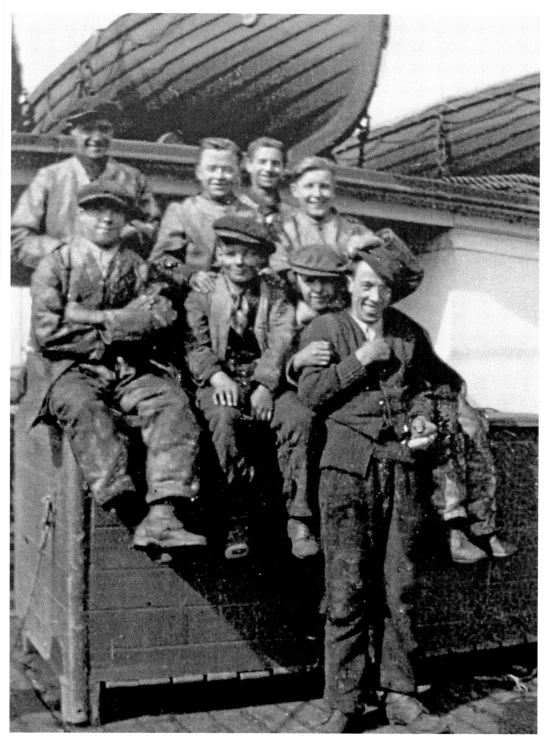

Seamen working out of the port of Barrow.

with and the Irish population felt this most keenly. This reached fever pitch in 1864 when there were anti-Irish riots. The Irish had come to the town early on, helping to build the railway and later the docks, providing general labouring. Often they were paid low wages and given poor housing, sometimes being discriminated against with lower wages than English workmen.

A larger influx arrived to work on the dock construction and in the shipyard. This caused dissention and protest from the locals. The *Barrow Herald* remarked that a number of 'roughs' whom 'we should be ashamed to call Englishmen', had set upon the Irish navvies, 'who had come here to earn bread by the sweat of their brow'. The cause of the conflict was the allegation that the Irish were undercutting the English by accepting lower wages. However, the crux of the problem had actually been an altercation between a Scot from Dumfries and an Irishman called McManus, who had banged into each other with their wheelbarrows. Insults had been hurled – including the word 'Paddy' – which had ended in a general fight. Whatever the true cause, the result was unsatisfactory for all as it forced wages down to give parity to all. This would not be the last dispute; in fact in the early twentieth century it became common.

Naturally, as the port grew (though never quite to the optimistic level hoped for by Gladstone, who declared it could be the new Liverpool) so too did new innovations. The opening of the Barrow Flax and Jute Company in 1874 provided work opportunities for women and girls. Jute was imported to Barrow from Calcutta and the industry produced rope, cable and other items such as carpets and rugs. It employed up to 2,000 females, frequently

Barrow Island and shipyard (picture S. Patience).

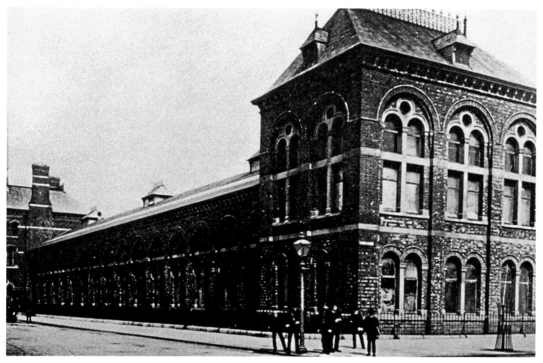

Barrow Flax and Jute Works.

drawn from the growing Irish community. The mill had its own branch line which connected it to the docks, steelworks and corn mill. The industry was a stalwart attempt to diversify and provide alternative occupation to the iron and steel industry. Unfortunately, the factory was subjected to two damaging fires in the late 1800s and coupled with a rise in competition from India and Dundee, the business ultimately failed. The huge site became Lakeland Laundry and the John Whinnerah Centre, which were both places of employment. These too have passed into history and The Range and Age UK now occupy the site.

Wood and wood pulp were imported to the docks from Norway and were unloaded ready to deliver to Salthouse Mills, which was built in 1890. Barrow Chemical Wood Pulping Company had located the factory close to Cavendish Dock, presumably for ease of transport. The mill was another place which could employ women and it endured for many years, carrying on its work into the twentieth century. Cavendish Dock was the final of four docks created in Barrow (after Buccleuch, Devonshire and Ramsden), around 1878, and was a sign of lasting optimism. It never quite realised its full potential, despite being the largest of the docks with highest capacity. For a short time it was the base for an airship construction facility, but this did not last long. It never rose above being a feeder dock to the other docks and its cost far outweighed is usefulness and profit margin. This was a great disappointment and finally put to bed the idea of Barrow rivalling Liverpool. Eventually, the dock was abandoned in preference for dredging Walney Channel and monitoring the deep water berths there. Cavendish Dock was sealed off and became a reservoir and is now used for fishing and wildlife conservation.

Barrow Steam Cornmill Company was established in 1870 at the peak of the industrial growth in Barrow. William Gradwell, a prolific builder in Barrow, was assigned to build

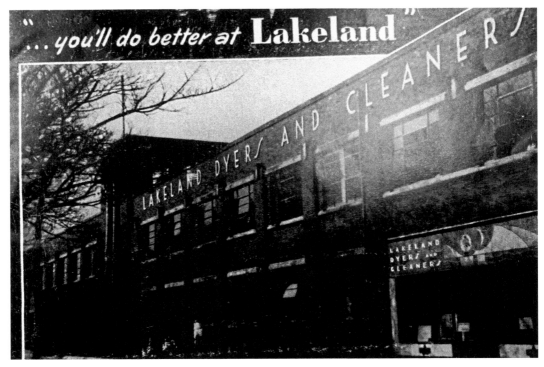

Lakeland Laundry on the site of the Jute Works. (Courtesy of Barrow Archives)

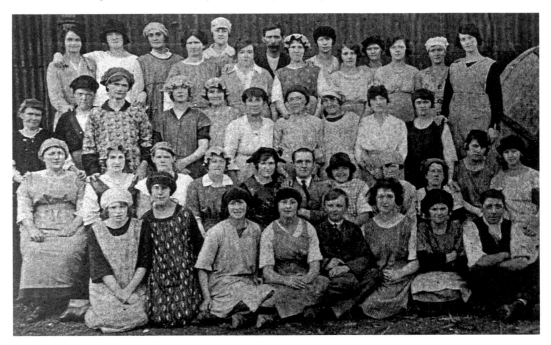

Paper Mill workers in the 1930s. (Courtesy of Kay Parker)

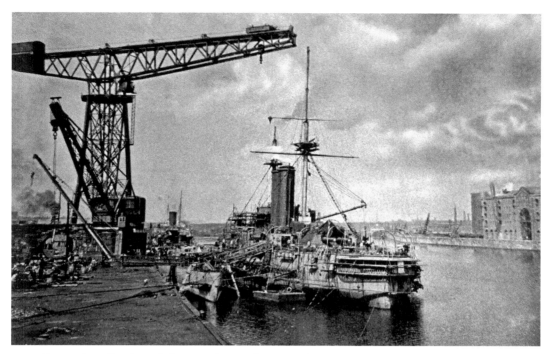

Devonshire Dock, with Barrow Steam Cornmill Co. on the right.

the mill. It was very successful for a time and expanded, but soon fell into financial difficulties. The company was sold on to Walmsley & Smith Ltd in 1880; the mill was modern and innovative and was the first building to install electric lighting in the town. Later, in 1903, they were subsumed into Edward Hutchinson Ltd from Liverpool. The large warehouse was eventually replaced by a silo system as production increased. However, by the 1960s it had been reduced to a department within the larger company, producing animal feed. It closed in 1967 and the derelict building went the way of many others in Barrow and was destroyed by fire in 1972.

The steel industry began to flounder in the 1880s for a number of reasons. After the early optimism and entrepreneurism, not to mention the huge investment, a period of uncertainty hit the town. Job losses had an impact and production was inconsistent. The steel-making process rolled the molten steel to reduce its thickness and produce uniformity; this was made into things like steel rails and was exported worldwide. Newer processes emerged using lower quality ore and posed major problems for the Barrow steel making; in short, they could not compete. Additionally, import costs of coal made the steel production more expensive. The confidence in the industry wobbled but at the same time opened up opportunities for diversification. One area which thrived for a time was the Hoop and Wire Works. The Askam furnaces shut in 1918, never to reopen. The Barrow steel production staggered on for years, occasionally producing record levels of pig iron, but the writing was on the wall and in the twentieth century its demise was complete.

A growing town needed adequate suppliers and merchandise, and the shopkeepers responded to this. Dalton Road was packed with small shops, each proclaiming their products to be the best. Small independent shopkeepers purveyed everything from bread to tobacco.

Barrow Cornmill and crossing. (Courtesy of Barrow Archives)

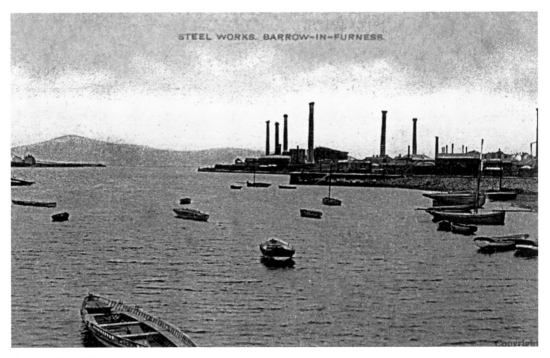

Barrow Steel Works.

To reach the widening population there was also a market, behind the Town Hall. A beautiful iron and glass market hall was built and it was full of various goods. Outside, market stalls offered even cheaper options and even greater choice. Small cafés and restaurants opened and were as popular as the fast-food options we have today. Naturally, in a town principally made up of men in the early days, public houses were prevalent. It is said that there was a pub on every corner. Some were basic places for workers but as the social scene changed over time, some became gentrified and boasted extra facilities, such as the bowling green at the Ormsgill Hotel!

Public houses were sometimes hotels as well, and on inspecting the 1881 census it's possible to see the variety of residents who stayed in these establishments. Charles Bleasdale was the publican and proprietor of the Victoria Hotel in Church Street, his family are living in, but there are other people staying there. These included three domestic servants all hailing from Cumberland and Lancashire, a boot servant, and a waitress. The list of visitors demonstrates the commercial success of Victorian Barrow – residents came from as far afield as Baltimore in the USA, Bombay in India and Scotland, and included a 'Commercial Traveller' and two 'Electrical Engineers'. Charles Bleasdale also owned the Ormsgill Hotel, but unfortunately he fell victim to the 1880s slump and lost both hotels. Charles was bankrupt but his astute wife,

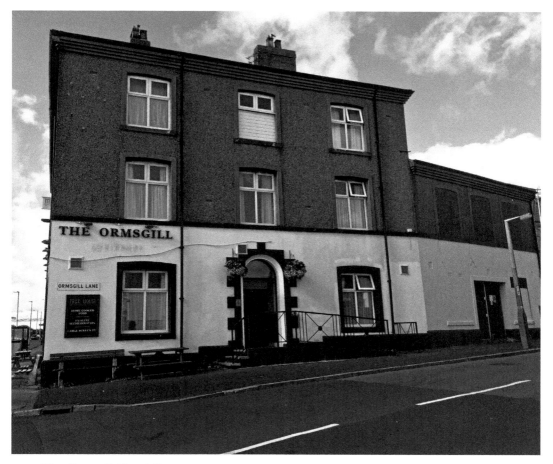

The Ormsgill Hotel, Barrow.

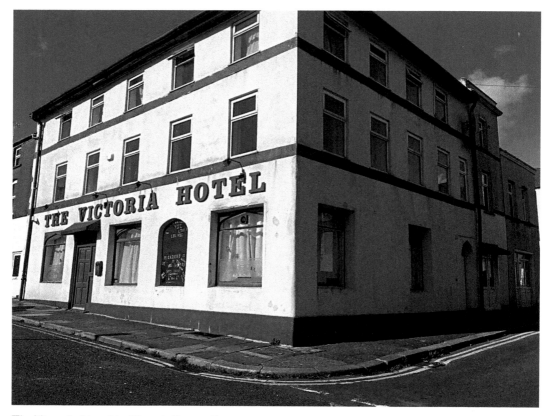

The Victoria Hotel in Church Street, Barrow.

Mary Jane, re-established their fortunes and they ran hotels at Fleetwood. When she died in 1927 she left more than £6,000, a house at Coniston and shares in Blackpool Tower – not bad for a quarryman's daughter from Kirkby.

HERITAGE: A NEW APPROACH

After the Furness Railway had begun to carry passengers the management realised that there was an opportunity to make more money by moving into the tourism industry. The tourist venue included the Furness Abbey Hotel, in the grounds of Furness Abbey. The railway ran right past the East Window of the church and further along was the station and buffet. The abbey was linked to the line which connected with Haverthwaite and the branch lines to the Lake District; this was an advantage and helped to draw visitors from the Lakes to Furness. Furness Abbey became a popular tourist destination and provided culture and history for the visitor. Inside the hotel were artefacts from the abbey and the gothic style of the architecture mirrored the abbey's medieval stonework. Furness Railway Co. capitalised on this and even provided a dedicated guide and custodian to take visitors on tours. The abbey was arranged with gates and paths to help the visitors reach the interesting nooks and crannies. The abbey lawns were cut short but there was still a lot of vegetation and foliage judging by photographs.

The Custodian's Ticket Office, built around 1910.

An early guidebook to Furness Abbey.

EARLY TWENTIETH CENTURY: THE IMPACT OF WAR

During the early years of the twentieth century not all of the industries which had burgeoned in the Victorian era continued to thrive. Iron ore mining was one which began to struggle. Deposits were becoming harder to find and less economical to mine. One by one the mines closed as the reserves depleted and there were problems with flooding the deeper they were mined.

A similar story was true of the steel industry. The processes were changing all the time and cheaper production could be found elsewhere; competition was fierce and the local industry gradually faded. Other allied businesses such as the Hoop and Wire Works grew from the diversification of the steel industry.

One industry which blossomed was shipbuilding. Vickers & Sons bought the Barrow Shipbuilding Company in 1895, transformed the yard and changed its identity a number of

Steel Works.
(Courtesy of
Barrow Archives)

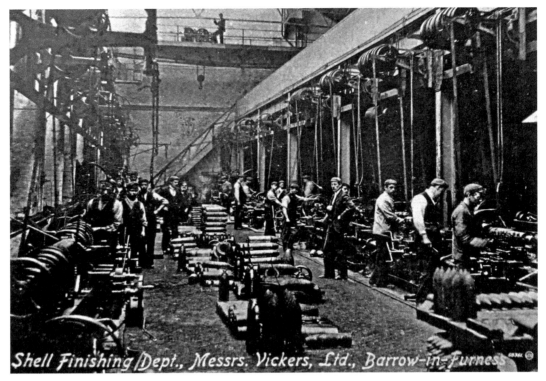

The Shell Finishing Shop at Vickers.

times through various mergers. During the First World War the shipyard worked hard to produce arms and vessels for use in the conflict. The contrast between the photograph of the Shell Finishing Dept and the ones of Shell Shop two and three is interesting. The earlier, pre-war photograph shows a completely male workforce, while the subsequent two images illustrate the changes in the employment of women for the first time. The traditional heavy engineering jobs were regarded as a male domain and it was only because of a relaxation of rules during wartime that we see women in these roles. Although women were now accepted as workers, the overseers were often male. The women came from far afield and in their thousands. Barrow's population rose to its highest ever level, which caused major housing problems. Lodgings were overcrowded and at a premium. Special transport was laid on to allow the workers to live in surrounding towns. By 1918 the numbers of workers had risen to 30,000.

Shell production was immense and the work was tough and not particularly well paid, but it was essential war work. The workers in the yard were exempt from military service because of the important nature of their jobs, and recruitment was discouraged in the town. Men were issued with badges to show that they were legitimately employed in war work and were not shirking their duty. It was as Vickers Armstrong Ltd that the company produced many ships, armaments and submarines which were essential to the war effort. However, even in wartime things did not always go smoothly. Longer hours and stricter adherence to rules were introduced under government directives. This caused disputes and problems. Barrow was already subject to difficulties over the objections of some of the Socialist leaders, such as

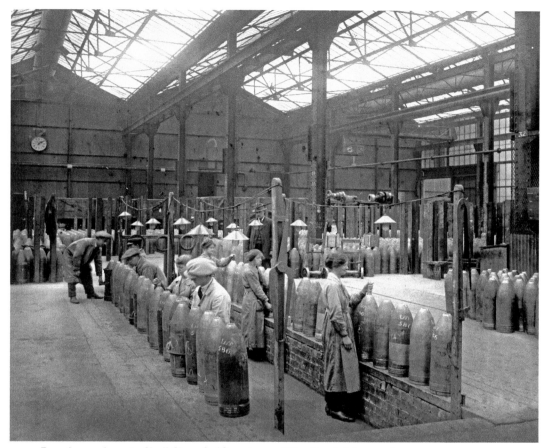

Female workers in Shell Shop 3. (Courtesy of The Dock Museum)

Bram Longstaffe, who refused to participate in any aspect of war work. They were imprisoned and this amplified the idea that Barrow was a 'Funk Hole' for people to hide from enlistment.

Disputes over unskilled workers and machine operators came to a head in 1916 when more than 5,000 workers went on strike for a week. This was contrary to the war effort and polarised opinion. An increase of shop stewards, many from known trouble spots in other yards, continued to inflame the situation. Another strike over the payment of productivity bonuses was held in 1917. This caused great hardship, particularly for the women who could not work because the men were on strike. A strike occurred again in the May of that year. The response this time was to look at the improvement of conditions and housing in the town. Things settled down, but the troublesome militants were waiting in the wings for future disputes in the years to follow.

The shipyard held opportunities for all kinds of employment, both skilled and unskilled. Following the First World War there was a national slump and this was compounded by the Wall Street Crash in 1929. There followed a series of closures, unemployment and mass emigrations. The population fell and jobs disappeared. At this time Hunger Marches to protest about the situation were undertaken. Barrow was quite a hotbed of dissent and groups of unemployed workers did what they could to register their feelings too. Men from Barrow, Dalton and Askam joined

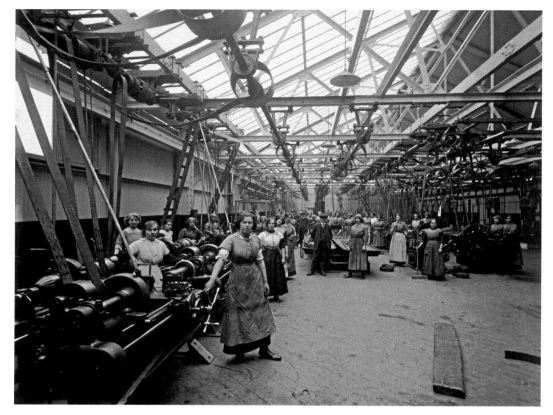

Female munitions workers in Shell Shop 4 during the First World War. (Courtesy of The Dock Museum)

together to cycle and walk to interview the Lancashire County Public Assistance Committee in Preston and to protest about unemployment and the ensuing poverty. A larger march to London was also organised to join up with other groups from all over the country; this was to petition the prime minister about the situation. The same groups of militant Socialists were involved in the organisation of these protests and there were rumours that there was Communist involvement too. Whatever the political motivation, the root cause was poverty, deprivation and the need for support to alleviate the unenviable position in which the working classes found themselves.

Many of the jobs in the shipyard were very specific and skilled; training for this work began early. Vickers had been instrumental in establishing the Barrow Technical School. Boys were trained from the age of eleven in the mysteries of engineering, drawing, welding and other skills to allow them to pursue a particular job in the 'yard'. Mrs Albert Vickers had laid the foundation stone, stamping the importance of the main employer on the building. Generations of boys passed through these doors and came out ready to take up apprenticeships which could last for five years. They were encouraged by their parents to get a trade because they would never be without work for long.

One such trade was a fitter. They were skilled in engineering drawing, machine assembly and construction and installation. In the yard they could find themselves working on shipbuilding, armaments or engines, and they were responsible for seeing projects through from start to finish.

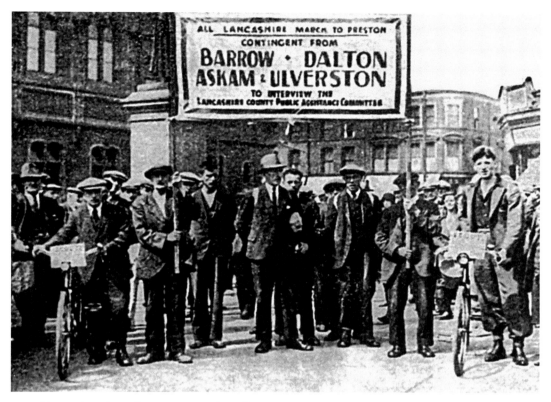

Unemployed men's protest march to Preston.

Barrow Technical School.

Fitters in the shipyard. (Picture courtesy of The Dock Museum)

Jack Taylor, a diver at Vickers, is seen here with some of the shipwrights he worked alongside. (Courtesy of The Dock Museum)

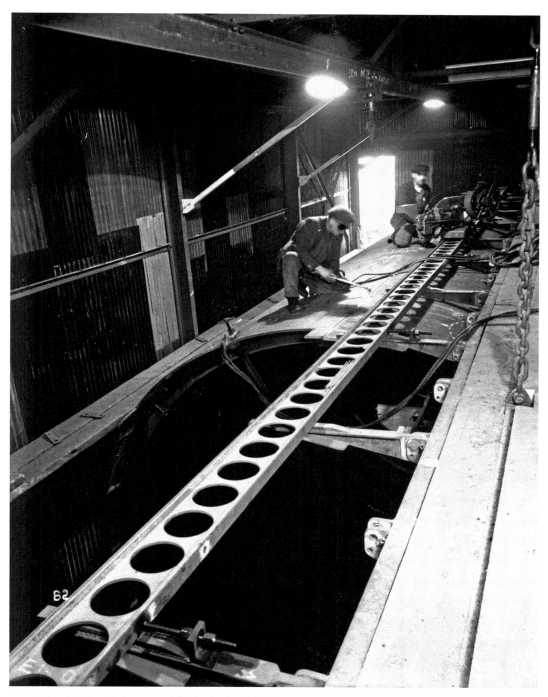

The A-Class Submarine HMS *Alcide* (P415) was constructed in 1943–44. The workmen are probably boiler makers and one is using a gas burner – he has protective goggles but no other protective clothing. His mate is looking on, with no visible protective clothing. (Courtesy of The Dock Museum)

The shipyard produced surface vessels and submarines and of course refitted and repaired ships too. This often entailed long hours in cold and wet conditions in the Victorian dry dock. Sometimes divers were employed to work below the waterline as well. The work was not without danger and conditions were often inhospitable. Workers who remember the dry dock recall that the sandstone steps which were slippery and lethal in wet weather. The dock was open to the elements and was slightly below sea level, so was not a pleasant place to work. Divers were necessary for inspecting and working on ships without using a dry dock. This was a hazardous job but it had to be done to assess the state of the hull and to estimate what repairs or maintenance were needed. The shipwrights were skilled men who worked on ship construction and repair, and were an essential section of the workforce. They had the important job of driving out the keel and the bilge blocks holding the weight of the ship prior to launching.

Ship and submarine construction increased during the Second World War. Vickers had produced submarines since the First World War and they were vital in the war against Germany. The Amphion or A-Class submarines had been designed for operations against Japan. Unfortunately, they arrived too late to be effective in war. They were streamlined and equipped with snort masts and were important as part of the submarine service until the modern P- and O-Class submarines came into service in the late 1950s. The HMS *Alcide* was 293 feet and 6 inches in length; it carried twenty torpedoes and had a crew of sixty-one. Alcide's surface speed was 18 knots and 8 knots submerged. It was launched on 12 April 1945 and was in service until June 1974, when it was scrapped at Hull.

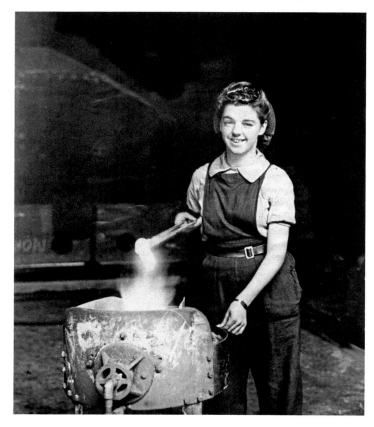

Mary Smith demonstrates rivet heating during the Second World War, a job which would normally have been done by young boys. (Courtesy of The Dock Museum)

As in the First World War Vickers took on female workers during the Second. This was not opposed because it was an accepted part of the war effort. The jobs in the shipyard were again 'reserved occupations' and it was recognised that this was vital work. By 1941 women aged between sixteen and forty-five had to register as 'mobile' if they did not have children to look after. The work was essential war work and many women opted to work there rather than being sent elsewhere. The shifts were long and the hours unsocial; the completion of ships was rapid and the work was constant. Some of the jobs the women undertook were traditional male roles, including rivet heating, a job which would normally have been done by young boys. Riveting squads were part of the Boilermakers Society and were one of the various 'hull' trades. The squad would consist of a heater, catcher, holder-on and a riveter. Sometimes there would be a left- and right-handed riveter; payment was assessed by the number of rivets placed. Riveting was the method used to join and seal metal. This has since been replaced by welding.

THE CO-OPERATIVE SOCIETY

The Co-operative Society had its beginnings with the Rochdale Pioneers in 1844. The idea was based in ethical fair trading. Customers were able to participate in the dividend scheme which rewarded them for their patronage. The Rochdale principles are still practised today and the Co-operative movement continues to pursue ethical trading, ensuring that goods are sourced honestly and fairly, and that neither customer nor farmer is taken advantage of.

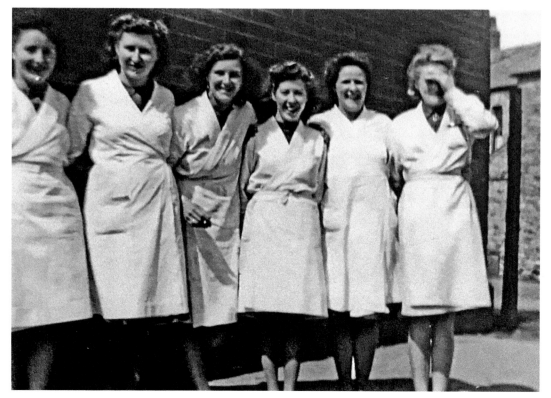

Female wartime staff at Askam Co-operative Society. Joan Bleasdale is third from the right.

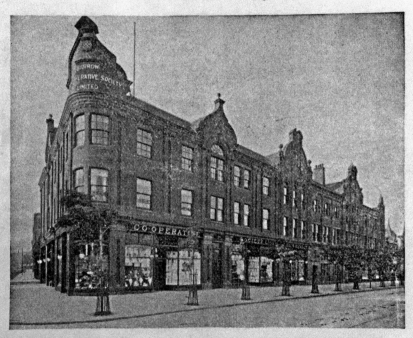
An advertisement for Barrow Co-operative Society.

The Co-op has been in evidence in Barrow for decades. With the advent of cheaper superstores it has reduced its outlets and is not as prominent as it once was; however, it can still be found. The Society held a prominent site on Abbey Road from 1889, in an impressive building with three floors. It contained most household goods, clothing and merchandise you could want and endured until 1996, when it sadly closed. A Wetherspoons' pub opened in 1998 and in 2015 its upper floors were converted into a fifty-two-room hotel. As a nod to the past the pub is called The Furness Railway and is full of pictures and memorabilia from the Victorian history of the town.

Further up the road was the Co-operative Restaurant, which claimed to be the 'best appointed café in town'! It was a pleasant and well-turned-out establishment with waitresses dressed just as smartly, similar to the famous Lyon's Corner House nippies. This café lasted for many years but finally disappeared with other such establishments, giving way to less illustrious fast-food outlets. The Co-op had a series of smaller shops in the towns and villages and there were many in the Barrow area. Askam still has a Co-operative store in Duke Street; this began in 1868 – serving the mining and industrial workers in the villages of Askam and Ireleth. The shop was brimming with goods and met the customer's every need. During the Second World War, when most of the male employees were serving in the forces, women were employed to take their places. This period was a difficult one because of rationing, but the approach in the shop was happy and positive. Following the end of the war the female employees were let go, in order to give the men their jobs back. Luckily, some found employment in local factories or other shops, but it must have been a sudden and unwelcome change to their lives.

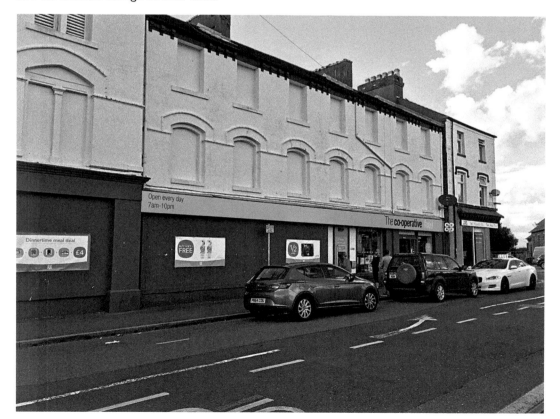

Askam Co-operative Society, Duke Street, Askam.

HEALTH

Since the Crimean War (1853–56) and the nursing revolution that followed Florence Nightingale's reforms, nursing had become a respectable career for women. The first two hospitals in Barrow were not much more than cottage hospitals and would have had few fully trained nurses. During the First World War there was widespread recruitment of nurses to meet the needs of the war casualties. Women were often recruited to nurse at the front and they were trained quickly. It was a time of great change, and new skills and treatments were developed. Convalescence was important for those soldiers with shell shock and amputations. A hospital was established at Conishead Priory and soldiers were billeted there.

However, by the 1930s there was a professional training school for nurses at North Lonsdale Hospital. Accommodation was provided in Albert Street from 1921 and the training school continued until the hospital closed. The regime was strict and the nurses had to follow rules which prevented them from entertaining gentlemen and staying out late. They had to present a smart and clean appearance at all times and they were expected to follow their duties diligently.

Dorothy Wilkinson was a nurse at North Lonsdale in the 1930s, where she completed her training. Later in her career she left to nurse in London where she worked in a number of large hospitals, nursing such patients as the singer Jessie Matthews and Winston Churchill. Nursing was a lifeline for many young women of this generation as many, like Dorothy, were spinsters. Following the First World War there were more young women than men and marriage opportunities were limited. Nursing allowed a certain level of independence and one could rise through the ranks, making a good career. Recruitment increased again during

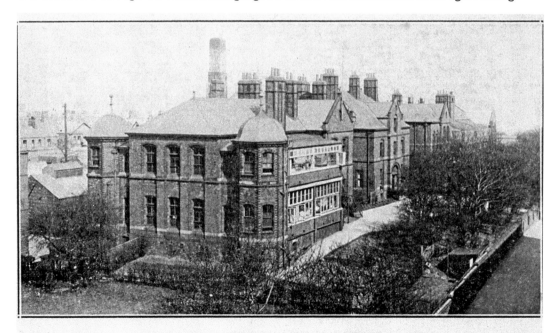

THE NORTH LONSDALE HOSPITAL.

North Lonsdale Hospital.

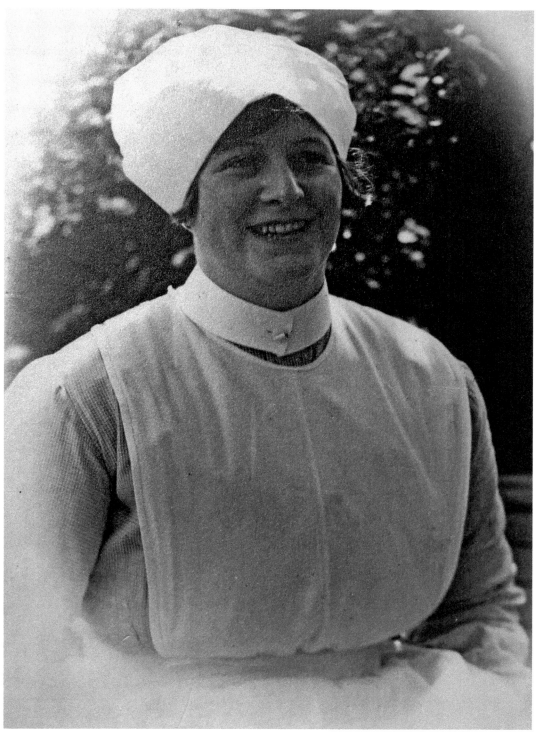

Nurse Dorothy Wilkinson.

the Second World War and this was often accessed from serving in the St John's Ambulance Corps or other such work. This gave women the opportunity to apply for nursing posts and take up the career professionally, which continued after the war was over.

COMMERCE

From early in the Victorian era there was great confidence and optimism in the town. The founding fathers, such as Ramsden and Schneider, were keen to propel it into an effective commercial success. The investment opportunities were manifold and people were keen to put down roots in this new urban gem. Naturally, to support the industry and business in the town, commerce and banking grew as well. Duke Street was predominantly the commercial area and until the 1980s most banks and accountants could be located there. Many of these have been transformed into bars or offices and the grand temples to Mammon have given way to modern, streamlined building with ATMs along the main shopping street, Dalton Road.

It will surprise many people to discover that Barrow had its own stockbroker's office. This was located at 115 Duke Street and was called Twentyman's Stockbroker. The business was run by Robert Twentyman, who was born in 1882. The young Twentyman was ambitious and bright; he started out as a Municipal Clerk and had progressed to Municipal Accountant by 1911. He was active politically and was involved with various groups such as Rotary and the Freemasons. He was initiated into the Hartington Lodge (the oldest Masonic Lodge in Barrow) on 8 February 1910. He became Master of Hartington Lodge in 1921 and eventually

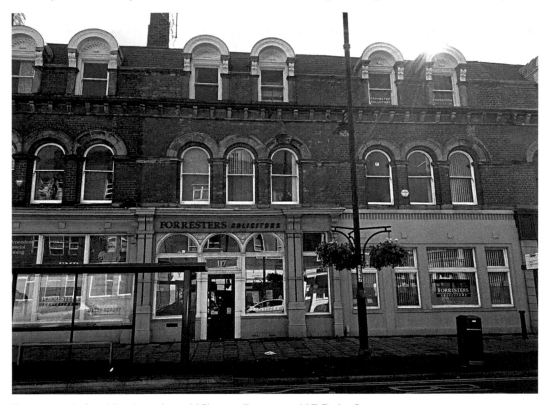

Twentyman's Stockbrokers (was 115) now Foresters 117 Duke Street.

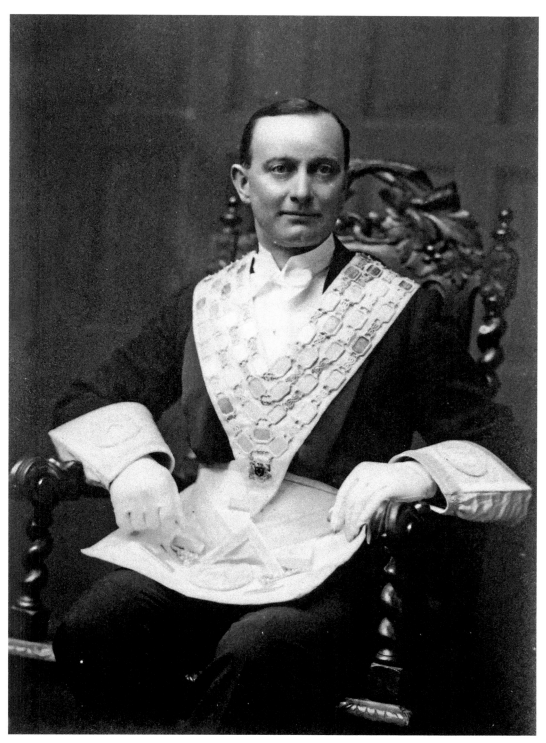

Robert Twentyman.

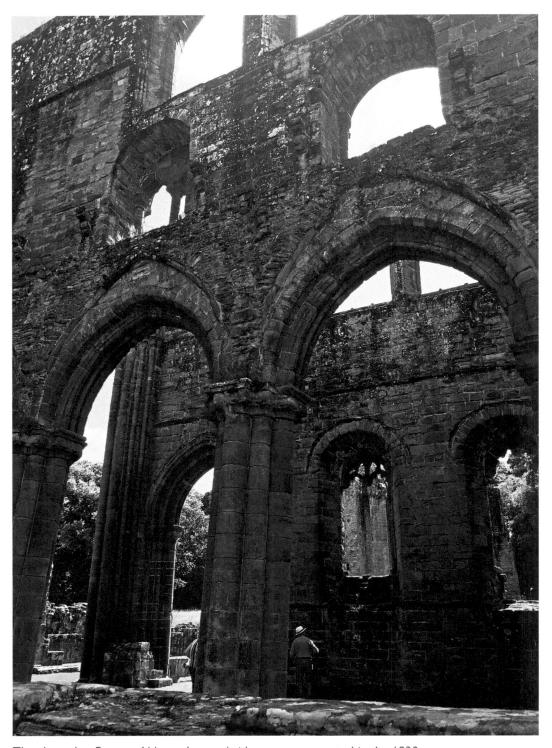

The chancel at Furness Abbey, where subsidence was corrected in the 1930s.

rose to Past Grand Director of Ceremonies. He was president of the Barrow Rotary Club in 1941–42. He had established his own stockbroking business, located next door to Forrester's the solicitor. He was involved in the commerce of the town but he was also a philanthropist and believed in giving back to the community. He married but the union produced no children.

Heritage management was in its infancy in the early part of the twentieth century and Furness Abbey was one of the significant buildings to come under the care of the Department of Works. It had been signed over to the nation in 1923 by its owner, Sir Richard Cavendish, with the proviso that Barrow ratepayers were to have free access to the site. Furness Railway had previously used it as a tourist attraction but by the 1920s an active approach was undertaken to promote historic sites. With this came the responsibility of conservation. This was undertaken by builders and masons, locally employed and skilled in their craft. However, their daring almost outstrips their skill; especially when one looks at the manner in which they corrected the massive subsidence issues in the presbytery. Using block and tackle, ropes and cement, these workmen (sans hard hats) stripped back the massive columns in the transepts and built brick supports around them. They then filled them with concrete and carefully replaced the stonework. They even ensured that the twist in the columns remained and then they removed the brick piers. This stabilised the building and was a forerunner to the massive issues twenty-first-century workers and archaeologists faced, under the direction of English Heritage.

POST-WAR PERIOD UP TO THE END OF THE TWENTIETH CENTURY: A BRAVE NEW WORLD

Following Robert Twentyman's death in 1964 his business partner, Miss Margaret Cowan, took over the business. Born in 1927, she was a second generation Barrovian, her parents both originally coming from the Lake District. After leaving Alfred Barrow Higher Grade School she attended Spennythorne College and learnt shorthand, typing and business studies. Mr Twentyman had employed her as a secretary and stock clerk, but soon realised her potential and encouraged her to apply for membership of the Stock Exchange. She became one of the first female stockbrokers in the United Kingdom and was interviewed by the national press. She was a sole trader for many years until the Stock Exchange changed their operating rules and she amalgamated with two other brokers. The climate was changing too and the bespoke service was being offered by the banks. By then she was a member of Neilson-Cobbold of Liverpool. She continued in business until 1992, when she retired, and was a much-respected businesswoman and a member of the Soroptomists, who work to transform the lives and aspirations of women. She died in December 2006.

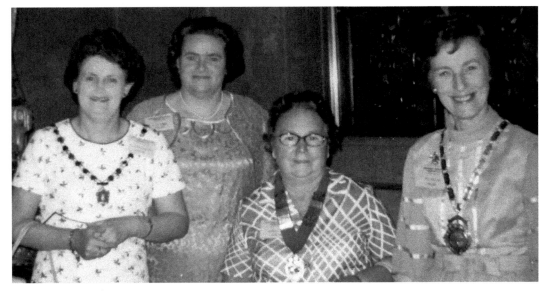

Miss M. A. Cowan (second from the left) with fellow Soroptomists.

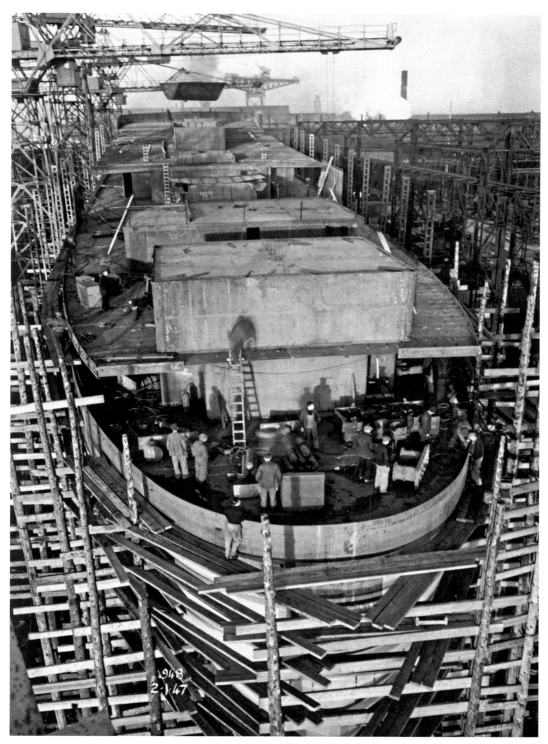

Accra under construction in 1947. (Courtesy of The Dock Museum)

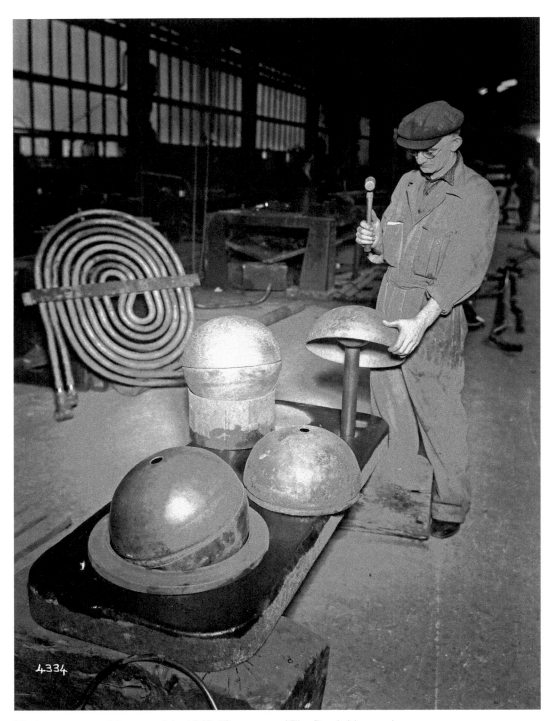

Marine coppersmith at work in 1948. (Courtesy of The Dock Museum)

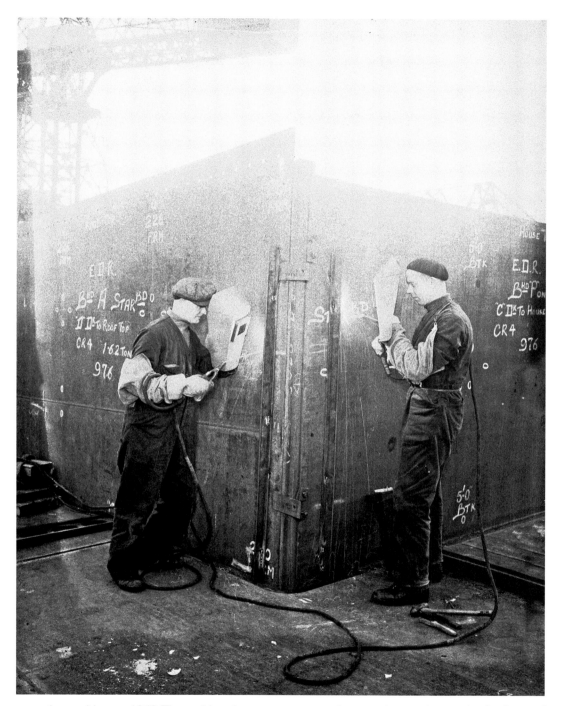

Arc welders, *c.* 1949. The welders have some personal protection equipment in the form of gloves, arm shields and masks. (Courtesy of The Dock Museum)

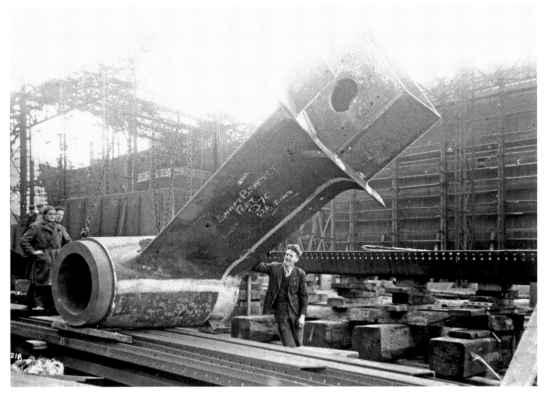

The *Hinemoa* is prepared for launch in 1948. (Courtesy of The Dock Museum)

Vickers foremen and managers in the 1960s. The author's father, Sam Cowan, worked for most of his life here (fourth from the right).

The shipyard continued to provide jobs post-war but the vessels built were diverse. One ship was the 10,700-ton liner *Accra*, which was designed to provide a round-trip service from Liverpool to West Africa. The photograph shows the ship under construction on the slipway. The week before the launch braziers had been kept alight to ensure that the tallow and soap which had been spread on the slipway didn't freeze. It was 471 ft long and was designed to carry both goods and passengers, with 245 cabins for first-class passengers each with showers or bathrooms. Other facilities included a dining area, lounge and seating areas, a library and even a chapel.

On launch day (25 February 1947) all went well and the weather was good. Mrs Creech Jones, wife of the Colonial Secretary Arthur Creech Jones, named the ship. It completed 171 trips and after twenty years' service in 1967 it was removed to Spain to be scrapped.

Marine Coppersmiths are skilled workers who shape and form copper into a range of items such as pipes and tubing. The employee would have to make things like condenser heads and piping from large sheets of copper. Originally, coppersmiths created all their own copper piping, but these days they are supplied with them readymade. They are able to create fittings for ships and submarines and they work to engineering technical drawings. Coppersmithing was just one of many metal working trades within the shipyard. Others included sheet metal workers, plumbers, pipe fitters and welders.

The *Hinemoa* was constructed at Buccleuch Dock for the Union Steamship Company of New Zealand. It would become an inter-island express steamer. It was launched in May 1946 by Mrs N. S. Falla, the widow of the managing director of the shipping line. The deputy prime minister of New Zealand, Walter Nash, was in attendance. The boat was put into service following its maiden voyage to Port Said, Colombo and Fremantle. She had a busy career carrying cargo and passengers and was refitted twice. Her final sailing was in 1966 and following that she was used as a hotel ship and an electrical power ship until she was towed to Hong Kong in 1971 for scrapping.

Welding was a better and quicker way of joining and sealing metal panels together and eventually replaced riveting in the shipbuilding process. It was less time-consuming than riveting and more streamlined. Large submarine sections were welded in the 'shop' and then lifted out to be assembled on the berth. This could be problematic and heavy cranes had to be employed. The partly fitted sections were then welded together and prepared for launching. This method of construction allowed for speedier completion times and during the Second World War it reduced the time from forty-four weeks to sixteen weeks. At the end of the war they were producing a submarine every twenty-five days. This efficient process allowed the yard to be very competitive and to look towards a positive future.

By the 1960s the shipyard had split into two separate entities, the shipbuilding works and the engineering works. The shipbuilding side continued to produce world-class ships and submarines, while the engineering side diversified. They manufactured equipment for the seagoing vessels but also took up contracts outside such as machinery construction, winding gear, armaments and component parts of Sulzer engines. These were often made in the General Machine Shop (GMS) – a huge Victorian work shed with twelve double-sided bays of machine tools, a wide gangway and rail track which was connected to the national rail system. The author's father, Sam Cowan, worked for most of his life here. He was apprenticed here as a fitter at the age of fifteen. (His brother Bill Cowan was apprenticed as an electrician and worked on the shipbuilding side.) Sam joined the Royal Engineers in 1946 and went to post-war Singapore, Burma, Malaya, Japan and Egypt, working on a variety of engineering projects. After other employment elsewhere he returned to Vickers Shipbuilding Ltd, becoming a Quality Control Inspector until he retired in 1987.

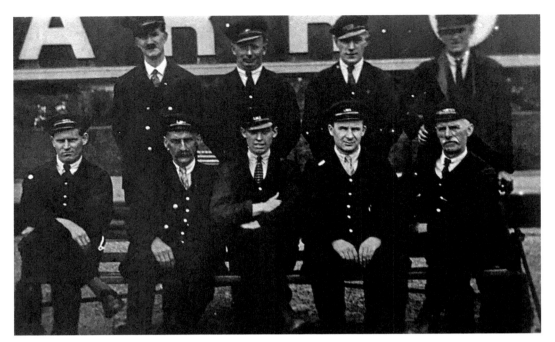

LMS staff at Barrow station in the 1950s. Parcel porter Ben Cowan is first on the left front. He and his brothers had worked for Furness Railway and he continued on the railway until 1957, when he died at the age of sixty-two.

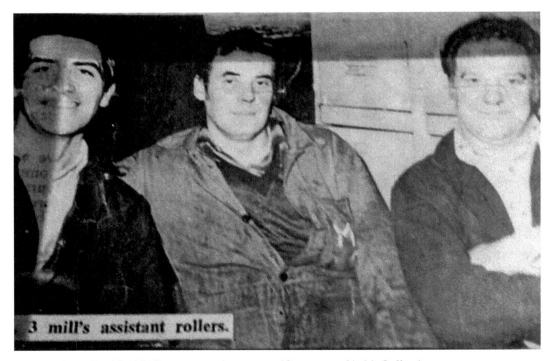

3 mill's assistant rollers.

Steelworkers: Freddie McCarten is in the centre. (Courtesy of L. McCaffrey)

Between 1982 and 1986 a new wave of work regenerated the shipyard. However, like many other major projects, other work arose from the construction. The Devonshire Dock Hall, fondly known as 'Maggie's Farm' after Margaret Thatcher, the prime minister at the time, heralded a change in fortune for the shipyard. This building was the biggest seen in Barrow at 51 m high, 260 m long and 58 m wide, covering 6 acres of ground. The Devonshire Dock Hall (DDH) is visible for miles and dominated the townscape. To build the DDH part of the dock had to be filled in with 2.4 million tons of sand. The purpose of the hall was two-fold, to provide cover for the vessels under construction and to prevent satellite photography observing the nature of the work. The DDH was first used to construct the Vanguard class submarines (Vanguard, Vigilant, Victorious and Vengeance). It has been in constant use since. The workforce rose to 14,300 by the end of the construction of the hall. The Trident submarines were constructed in the DDH and it is often called the Trident sheds. Sadly, the good fortune was short-lived due to a strike in 1988. This action echoes other periods in the history of the shipyard, with employment and production rising and falling like the waves.

Furness Railway had been the catalyst for Barrow to grow and was an important company in terms of investment and industrial development. However, after investing in the ambitious schemes to expand the dock system it found its reserves depleted and eventually the business profits reduced. The company was bought by the Midland Railway. In 1923 the company merged with the London and North Western, Lancashire and Yorkshire, and several Scottish companies. This conglomeration was the largest commercial group in the British Empire. The company was the largest of the four rail companies in the United Kingdom. It was nationalised in 1948 becoming British Rail.

One of the prime industries and a large employer was the steel industry. Freddie McCarten was born in 1931 in Hindpool at the centre of one of the industrial parts of Barrow. He left school at the age of fourteen, as many did in those days, and began his working life in Vickers Shipbuilding Ltd. Following his two years' National Service he was employed in the steelworks, remaining there until its closure in 1980. He worked in Number 3 Mill and the Roughing Mill as a roller. The work was physically demanding, particularly because of the high temperatures the men worked in, and there are stories of the steelworkers being so dehydrated after work that they drank two pints of beer straight down in the local public house.

Freddie was awarded a cash sum of £25 for introducing an idea to increase production. In January 1979 he and his team set a record for the first time in twenty-five years for producing 103,036 tons of steel in a single shift. The workers were congratulated and their efforts were reported in the local press. Freddie received a long-service certificate (for thirty years) in 1976 and worked for four more years until the steelworks closed for good. The industry had struggled for a number of years and most of the evidence of its existence has been swept away, remembered in only a few street names, including Bessemer Way and Ironworks Road.

Following the Second World War there was a change in the industrial picture of Barrow. Some industries were living on borrowed time; others were rising from the ashes of the war. The largest employer was the shipyard, but naturally there was a reduction in manpower once the war had ended. The shipbuilding company was known worldwide and has managed to endure despite times of hardship, industrial dispute and anti-nuclear protest. By 1968 it was known as Vickers Limited Shipbuilding Group; in 1977 it was nationalised, but this did not last long. It returned to private ownership under an employee led consortium called VSEL. After numerous other transitions it finally emerged as part of BAE Systems and is now an independent division renamed BAE Systems Submarine Solutions.

British Steel Corporation

Teesside Division

This Certificate is presented to

F. McCarten

in recognition of

30 yrs

of valuable service and
as a mark of appreciation

MANAG

DATE 16 December 1976

Freddie McCarten's thirty-year employment certificate. (Courtesy of L. McCaffrey)

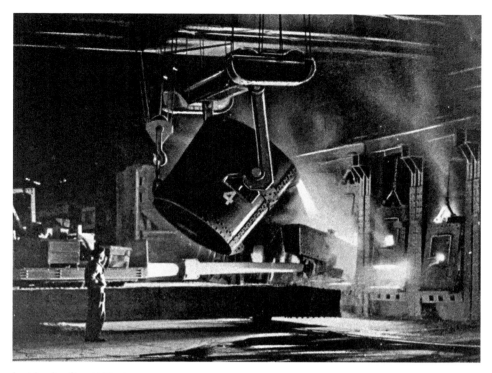

Inside the Steel Works.

Steel rolling mill.

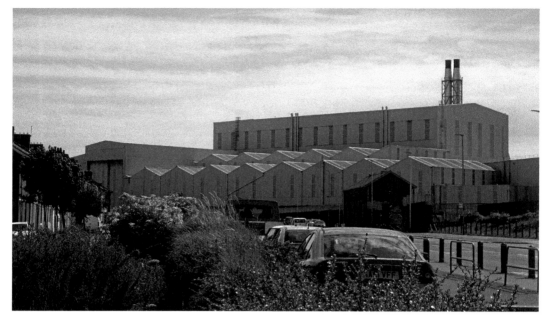

BAE Systems. (Courtesy S. Patience)

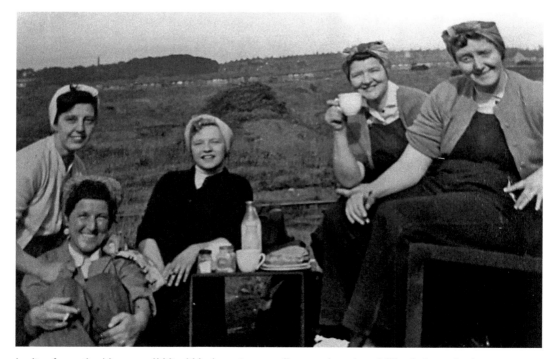

Ladies from the Hoop and Wire Works enjoy a well-earned tea break. The lady to the bottom left is Vera Chelton, who worked there throughout the 1950s until 1959. She later worked at the Paper Mills. In the middle is Daisy Potter, and on the far right is Joyce Martin. (Picture courtesy of S. Batty)

Derelict remains of the Salthouse Paper Mills.

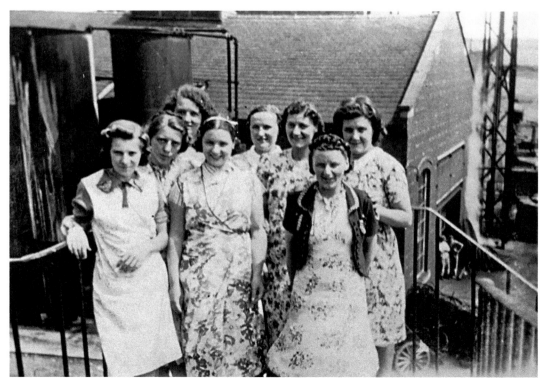

Staff at the Salthouse Paper Mills. (Courtesy of Kay Parker)

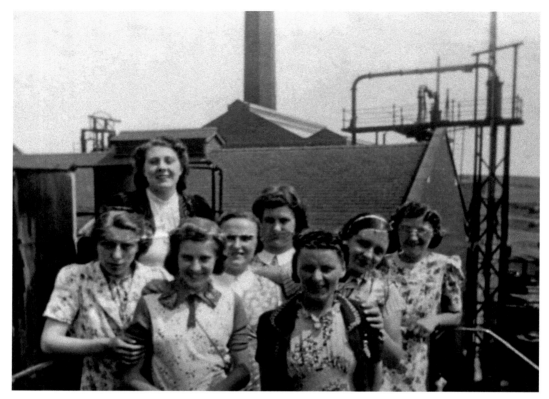

Staff at the Salthouse Paper Mills. (Courtesy of Kay Parker)

View towards Park Road where British Cellophane had their factory, with Walney Island and the wind farm in the distance.

The Wireworks (Cooke and Swinnerton) was acquired by the Haematite Steel Company in 1893. The factory produced steel hoops for binding wooden beer barrels and steel blades and coils for cable to be used abroad. The factory had a press to make buckles and its production was profitable. It became integral to the continuance of the steelworks in later years. There were still around 800 people employed by the Hoop Works but the factory itself was dated and in poor repair. A large investment would be needed to bring it up to speed and to modernise it. This was under review for some time and it became an unlikely hope. The works finally closed in 1982.

One industry which endured into the twentieth century was the paper industry. Barrow Chemical Wood Pulp Co., formed in 1888, was a long-established business which made the transition well. In 1919 the business became Barrow Paper Mills Ltd, producing high-quality paper for use in the printing industry. Naturally, the importing of wood pulp was important trade for the port of Barrow and when it closed down in 1972 its demise was keenly felt. Sheila Batty was a paper sorter and later a counter between 1956 and 1959. She recalls that there were two 'salles' or large rooms with benches for sorting paper. These were called 'places' and were where the sorters stacked the paper for counting and packing into reams.

The cutting machine, which was very dangerous, was operated by men. The sorters collected paper that was stacked on pallets brought up from the mill below. After sorting, the paper was piled on a table where a counter would count it into reams. These would be placed on the table to be wrapped and stacked. They would be placed back on pallets to be shipped out. The counter would record each ream the sorter completed. The sorter was paid on the quantity of paper they sorted. Each sorter had their own 'place' on the bench and on special occasions (like weddings) the places were decorated by the other workers. The work was relatively well paid and you were only able to acquire a job there if someone recommended you. One of the overseers was very strict and timed the girls when they removed waste paper down to the pulping machine. However, Sheila's memories are happy ones.

British Cellophane, which had been established in Bridgwater, Somerset decided to expand its interests and set up a new factory in Barrow. The modern factory was built on the outskirts of town with good access to the main arterial road out of Barrow. Although it was some way from the main residential areas it was often responsible for some pungent smells arising from the chemical process. Cellophane was revolutionary in its day and was extremely popular as a wrapping. The factory thrived from 1959 and was a large employer. Inevitably, it was taken over by the American firm Courtaulds and gradually the popularity of cellophane waned. In 1991 the decision was made to close the Barrow factory in favour of the Bridgwater site. This was a major blow to the local economy, with over 400 jobs being lost. Hundreds congregated to watch the demolition of the 120-foot chimney in 1995. A number of Barrow residents can trace their origin to the West Country once again, but this time Somerset not Cornwall. There was an exchange of personnel between the two factories and after the closure of the Barrow base some continued to live here, either seeking other work or retiring. Once again there is little or no trace of this relatively short-lived industry.

In 1968 a new factory along Park Road was built for Bowater-Scott Corporation. This main route into Barrow was prime industrial land. Bowater's was a large employer of machine operators, delivery drivers, office workers and other personnel; initially many of these posts were for men. By 1988, 1,200 people worked there. Kimberley-Clarke, an American company, bought Bowater's in 1995. Paper production rose to 115,000 tons of paper annually, which

Kimberley-Clarke Paper Mill – previously Bowater-Scott's Paper Mill.

The site of Lister's Yarn Company.

The improved main arterial road to Barrow.

Askam Brickworks, with Greenscoe Quarry behind.

Askam Brick Works.

K-Shoe Factory, Askam.

includes popular brands such as Andrex toilet paper and Kleenex tissues. Kimberley-Clarke continues to be a large employer in the Barrow area. This commercial paper mill outlived its counterpart at Salthouse, being able to upgrade and improve machinery and to diversify enough to meet the market forces.

Another factory which provided jobs in the post-war era was Lister's Yarn Company in 1947. The factory at Bridgegate was expanded in 1955 and again in 1963 and was a significant employer. The modern factory took up a large tract of rough brown field land covering some 18 acres. This was yet another opportunity for female workers in particular, as 'granny' shifts (evenings) and part-time working hours was offered, as well as more traditional full-time shifts. Joan Cowan worked in the packing department on the granny shift (5–10 p.m.) in 1967. She found the packing department quieter than the machinery shops in the mill. Lister's was closed in 1990 and 300 jobs were lost at a time of increasing recession; the local economy struggled with the loss of jobs and this was just the beginning.

The local MP, John Hutton, expressed concern in 1992 at the work and employment situation in Barrow. Over two years unemployment had risen to ten per cent. Lister's was one of many places shedding labour. There was a reduction in Defence spending which had led to 5,000 jobs being lost in shipbuilding. VSEL had ended the apprenticeship training scheme; in 1991 British Cellophane had closed, losing 400 jobs, and Bowater-Scott's Paper Mill had shed another 800. This post-industrial crisis was prompted by a number of issues, including poor transport links by both road and rail (a little ironic considering improved transport links and in particular the coming of the railway had been the initial reasons for growth in Barrow in the first place). Hutton remarked that for every vacancy there were up to seventeen unemployed applicants and as a comparison he said there had been 357 redundancies in Cumbria as a whole, of which 317 were in Barrow.

Askam Brickworks (Furness Brick) is a survivor from the nineteenth century; it has endured and is still in operation at the time of writing. The company was established in 1845 and is an independent family business located below Greenscoe Quarry. It is located on the improved road to Askam and is set back with extensive room for storage of its quality bricks. The factory is little changed and is a recognisable landmark and testament to the durability of a quality product and good workmanship.

Jim Price started work at the brickworks in 1954 after leaving school at the age of fifteen. He said the work was 'hard graft' manual work, which included outside work for up to four hours at a time – no matter what the weather. The tasks he undertook ranged from sieving rubble to remove the brick dust, to setting the kilns with several thousand bricks ready for firing. He had to use maths skills alongside physical labour to allow him to stack the bricks efficiently and safely, ready for transportation. The bricks had to be stacked on flat-back lorries so they didn't move or dislodge in transit (this was the 1950s – before the aid of plastic wrap). Jim worked for the company for ten years before moving on.

K-Shoes was a long-established boot- and shoe-making company in the nineteenth century in Kendal. The business had thrived in the Second World War, producing flying boots, shoes for the army and other government contracts and after the war they expanded. The Askam factory was established in 1953 in the old Yorke House Community Centre. The factory expanded across the site of the Askam gasworks and it became a significant employer locally. By the early 1970s the number of employees had risen to 1,000 but this fluctuated later due to the impact of new technology on the production process. Sadly, the industry began to falter from 1976 onwards, due to cheap imports, highly priced leather and lower demand. Job cuts, rationalisation of management and technological improvements held back the factory's demise but the end was inevitable, despite the production of 31,000 pairs of shoes every week in 1987. The factory was finally closed in the 1990s, the work being transferred to factories abroad.

HEALTH

By the 1950s nursing had become a professional and vocational role. North Lonsdale was a Voluntary Hospital under council management until 1948, when it became part of the Manchester Regional Hospital Board under the regulations of the National Health Service. The hospital was the main general hospital for the Barrow area; maternity services were at Risedale Maternity Home and Gynaecology and Geriatric cases were dealt with at Roose Hospital, the old Workhouse. Devonshire Road Hospital for Infectious Diseases remained too, but all of these hospital providers were amalgamated under one roof at the brand new Furness General Hospital in 1984. The hospital serves a wide area and employs a large number of nursing and medical staff, as well as ancillary and administrative staff.

The borough of Barrow-in-Furness had an autonomous police force between 1881 and 1967; before this it had been part of Lancashire Constabulary. Policemen in the post-war period were a visible presence and often well-respected individuals in the community. They pounded the beat and were involved in the day-to-day events of the community beyond the apprehension of villains. One such officer was Joshua (Joss) Dawson, who joined the police force in 1959 and served until he retired in 1989. He was the policeman on duty when a bull escaped and he was responsible for capturing the creature, which he did! Joss rose through the ranks and ended his career as an inspector.

North Lonsdale Hospital's Nurses' Home, now a nursing home for the elderly.

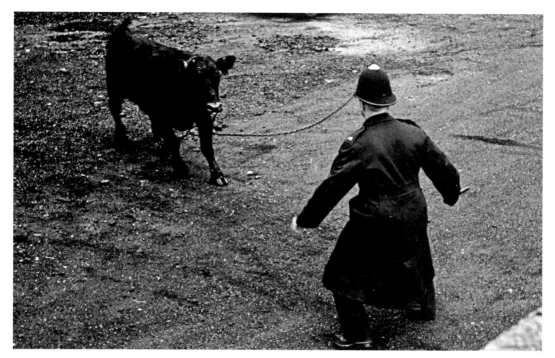

PC Joss Dawson tackles an escaped bull. (A policeman's lot is not always a happy one!) (Courtesy of D. Dawson)

BARROW DAIRIES

There were two main dairies supplying the local community in Barrow. The principal dairy belonged to the Barrow Co-operative Society, who had their main outlet on Abbey Road. In 1919 twenty local farmers set up the Barrow and District Dairy Farmers Co-operative Society Ltd in direct competition with the established Co-operative Society, and butter, cream and cheese would be produced from the milk supplied by the local farmers. After the Second World War the government created new regulations and standards for dairy production. The local consortium of farmers then created a new dairy to process the majority of milk produced locally in Furness.

The dairy opened on 12 February 1947 as the Furness United Creameries Model Dairy. It was completely up-to-date and contained the latest machinery necessary for the pasteurisation process. This was a unique venture where the producers and retailers were in control of the whole process, including distribution. Output was a phenomenal 1,200 gallons of milk per hour. Pasteurisation was then undertaken by heating the milk to 164 degrees Fahrenheit for fifteen seconds. This was then cooled to 38 degrees Fahrenheit. The dairies were moderate employers but important in the provision of protein and dairy products for the Barrow area. Around fifty employees worked at Roose Dairy and the facility could hold 40,000 bottles.

Roose Dairy eventually closed and was taken over by Deltawaite engineering firm. Other companies have offices there and everything has been done to preserve the outward appearance of the building. The building is in full use but has been adapted to suit the businesses therein – another example of adaptability and diversification. Even the Barrow Dairies logo is still visible on the chimney. Ironically, Woodbine Dairies now operate out of this building.

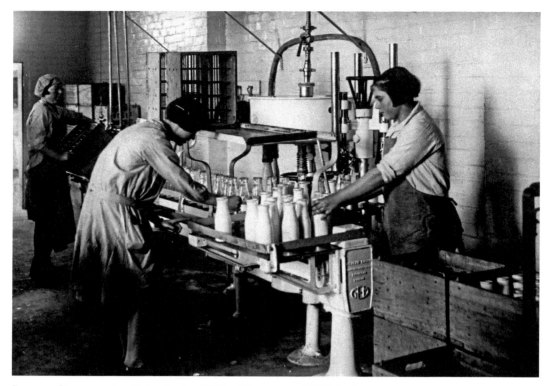

Barrow Co-operative Dairy in the 1920s. (Courtesy of P. Culley)

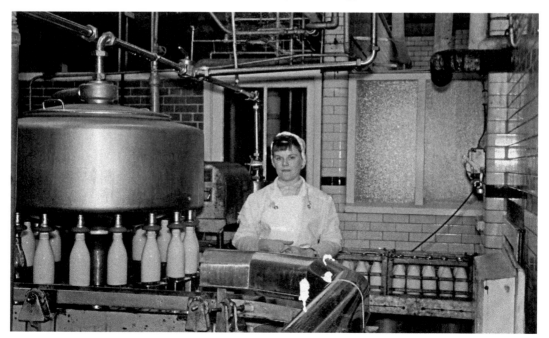

Barrow Co-operative Dairy in the 1950s. (Courtesy of P. Culley)

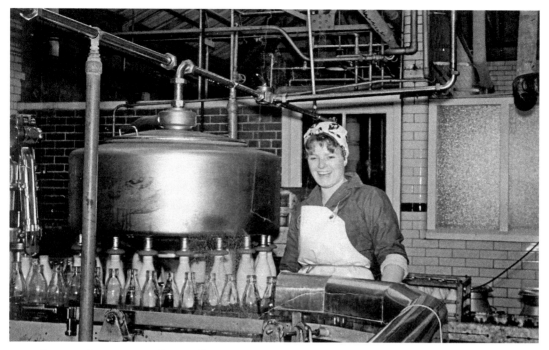

Barrow Co-operative Dairy. (Courtesy of P. Culley)

Roose Dairy.

LAKELAND LAUNDRY

The laundry began in 1890 in a small way, opening in Hindpool Road as Barrow and District Steam Laundry. It was started by Agnes and Walter Milligan and very soon their laundry developed and grew. Other laundries had been added to their portfolio at Grange, Kendal, Ingleton and Whitehaven. The business continued to expand and they added Carlisle and West Cumberland to the list. In 1937 a new laundry opened in Barrow on Abbey Road.

The business continued and it was a common sight to see Lakeland Laundry vans dropping off and picking up laundry from customer's homes. This service was popular, especially with larger items like curtains and bedding and endured until the 1990s. In 1972 the name was changed to Lakeland Pennine. The decision was taken to move the headquarters to Kendal in the 1970s and the Barrow laundry was left with offices, dry-cleaning and processing shop; about twenty members of staff lost their jobs at this time. The building became B&Q and later on The Range store. The building is now offices for Age UK and is an attractive Art Deco-style building.

English Heritage managed its historic properties in-house. Day-to-day maintenance was undertaken by employees who either moved around the properties or were actually based within them. One such employee was Tom Burrows, who worked at Furness Abbey for a number of years and became an identifiable and much-loved character. He was a familiar face and visiting schoolchildren were often treated to stories about the abbey and its buildings. Tom delighted in revealing 'secret' mason's marks to visitors. Tom cared about the abbey and tended the stones lovingly, weeding the ruins diligently; these tasks and more now fall to peripatetic ground workers who work at a number of sites. Tom spent many hours following retirement visiting the abbey; a testament to his love of the place.

Above left: Lakeland House. *Above right*: Tom Burrows.

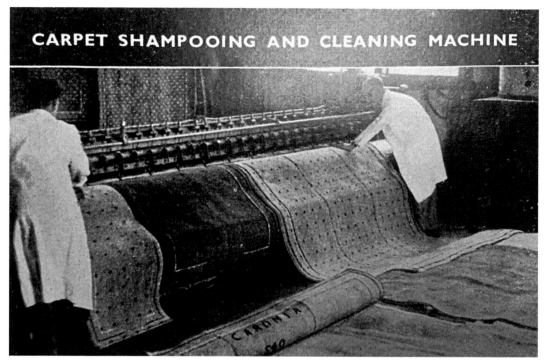

Cleaning carpets at Lakeland Laundry. (Courtesy of Barrow Archives)

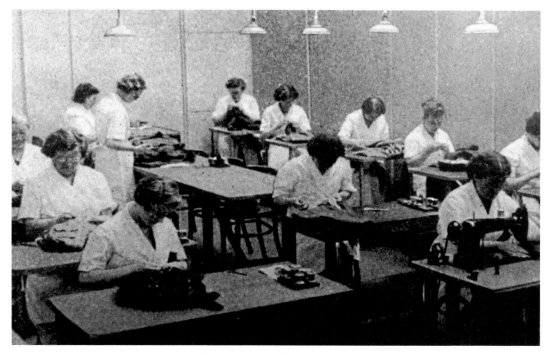

Seamstresses hard at work at Lakeland Laundry.

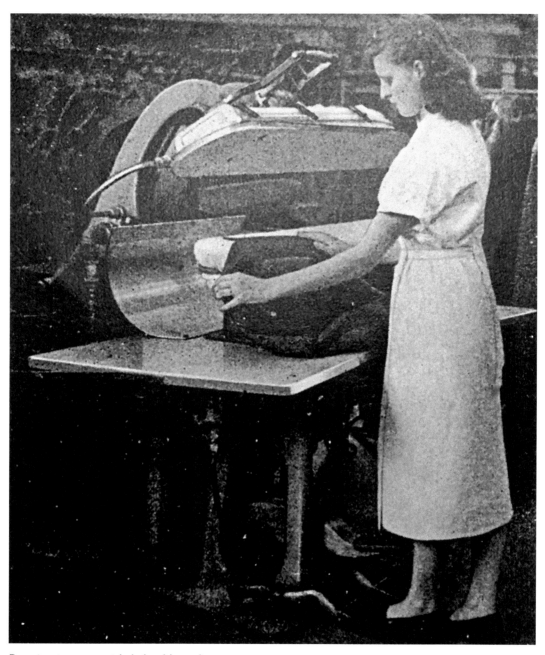

Pressing trousers at Lakeland Laundry.

Market traders have worked in Barrow since the nineteenth century. The market was a large Victorian glass structure, with covered stalls outside. This was a busy and colourful and in its heyday there were many traders and visiting stallholders. There was a designated meat and fish market which provided fresh, high-quality produce. Local farmers brought eggs

Heritage engineering work to correct subsidence in the presbytery at Furness Abbey.

and cheese, and the selection of other stalls included clothing, household goods, and almost anything you could possibly want. It was a popular shopping venue, providing quality, variety and affordable prices. The Victorian Market Hall was a pleasure to behold but sadly it was demolished, making way for the new market in 1971, which replaced Paxton Terrace and the area around Schneider Square.

The new market was opened by Queen Elizabeth II and it is one of the largest markets in Cumbria. Many of the foods are produced locally in Cumbria and there is once again a dedicated fish and meat market. There is an eclectic mix of stalls offering everything from balloons to pet food, and Tuk's Thai food stall even featured on the Hairy Bikers' Christmas Special show in 2011.

One popular trader was Alfred Edward (Ted Price) who worked in both the old and new market halls. Ted's stall started in one of the outdoor cabins and moved inside the Victorian market in the mid-1960s. He sold fancy goods, household-cleaning items and toys, and used to travel to wholesalers in Manchester every fortnight to replenish stock. The toy section of the stall was known as the 'half crown stall' because all toys were 2/6d (twelve and a half pence these days) and it was popular with children wanting to spend their pocket money. Ted's stall demonstrated change and adaptability, and the market has survived to the present day because the traders have responded to the needs of their customers.

SMALL TRADERS IN BARROW

Barrow was full of small shops at one time, providing great choice and employing many Barrovians. The independent traders were numerous and Dalton Road was lined with shops. Some of these have managed to survive, but many have not. The Hargreaves family were recorded as newsagents as far back as the 1911 census. Gertrude Hargreaves was listed as the newsagent, with Howson and Willam Hargreaves (her sons). The business was carried on by Geoff Hargreaves (Gertrude's grandson) until the mid-1960s. Geoff became a Director of Barrow AFC and ran the Bluebird Café at the Holker Street ground with his wife, Sheila.

Many small businesses have disappeared from the town over recent years. The Guselli family, who came to the town from Italy, ran a café and ice-cream shop from before 1900. By the 1950s the café had become a modern coffee shop, with booths and a jukebox. Young people would meet here and listen to pop music while having refreshments – it was certainly at the cutting-edge of coffee shops. Brother and sister Guido and Mary Guselli continued to run the business until it was sold to Mr and Mrs McGranthin. The shop has now been replaced by another business but the ice cream and coffee linger in older Barrovian's memories.

Heath's Ltd has survived all the changes in the town and is still the best place to find specialist art materials and stationery. The business began life over fifty years ago as a market stall, selling toys, second-hand books and comics. This family-run business moved to Paxton Terrace and later to its current Dalton Road location in the 1960s. The shop provides a wide range of books, stationery, art materials, toys and maps and hopefully will continue onwards with the next generation.

Hairdressers have always operated in smaller premises and although hairstyles have changed, the salons themselves continue to thrive. It is one area which large companies have been unable to impinge upon. One small salon which was representative of the trade was based in Friars Lane in the late 1950s. Marjorie Bailey (*née* Bleasdale) and Tommy Heffernan had trained together as hairdressers at a salon in Cornforth's Ainslie Street. During training

Geoff Hargreaves outside his news agency. (Courtesy of V. Vicich)

Heath's Stationers & Booksellers. (Courtesy of H. Jepson)

Marjorie Bailey and Tommy Heffernan's hairdressing and barber salon in Friars Lane.

Mary Guselli with the jukebox. (Courtesy of R. Guselli)

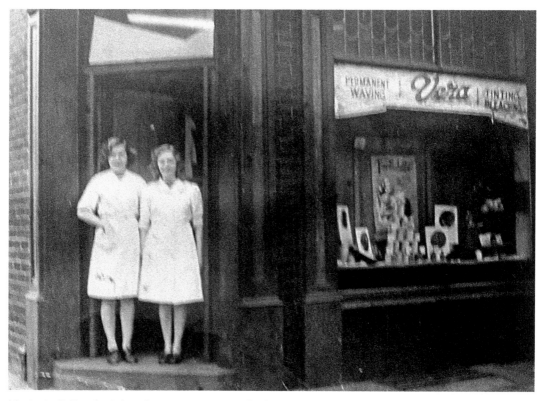

Marjorie Bailey (right) and an assistant outside the salon.

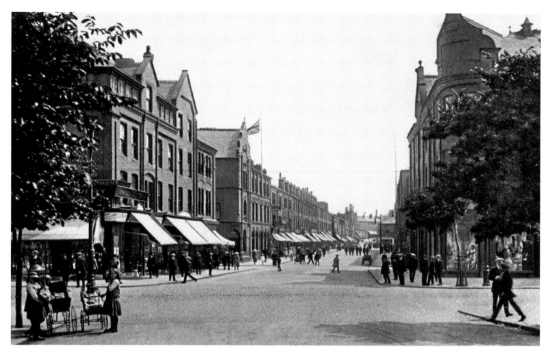

Dalton Road prior to pedestrianisation.

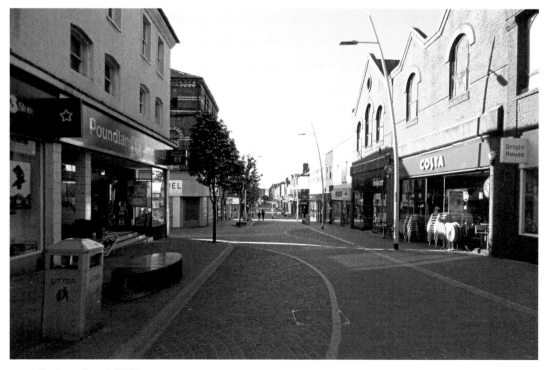

Dalton Road, 2017.

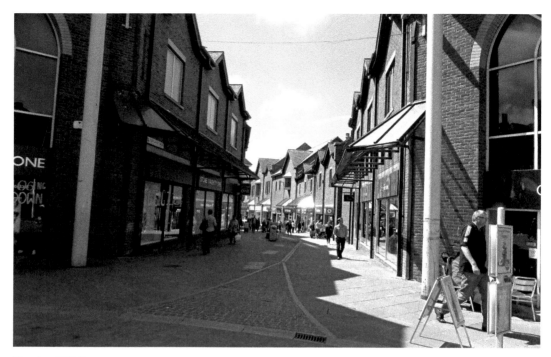

Portland Walk.

Cornerhouse Retail Park.

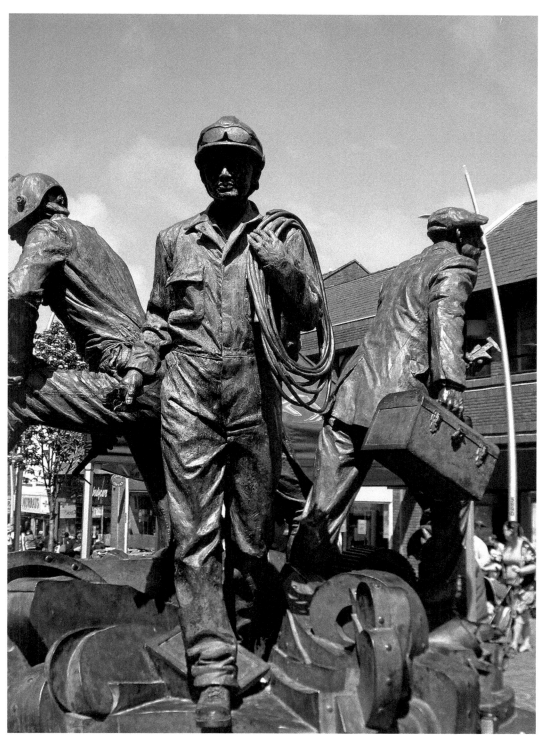

The 'Spirit of Barrow'.

Sowerby Woods Business Park.

Marjorie received no wages and after a time received her train fares, this was common practice in hairdressing salons at the time.

They set up business in Friars Lane in the 1950s and Marjorie worked in the upper salon, while Tommy had the lower barber's shop. The salon typically offered such delights as Marcel waves, perms, colouring, sets and cuts. The business continued until Marjorie left to have a family; she later left the district for Yorkshire, and only occasionally returned to hairdressing. Tommy continued to work for many years afterwards and he became a well-known barber.

The retail industry is one which has gone through a transformation in the last century. Barrow once had a thriving town and market with dozens of vibrant small shops lining its main shopping street, Dalton Road. Barrow was a popular town to visit as an alternative to the traditional market towns, like Ulverston. It survived unchanged for many years after the Second World War, but by the 1980s this was changing. The advent of supermarkets had begun to impinge on the small traders and alter people's shopping habits.

Other small outlets included Stern's dressmaking shop, where a myriad of fabric was sold alongside dress patterns galore. It was always busy and only declined when cheap clothing started to fill the market and the shops, and people were less inclined to make their own clothes. Greenock Sweet Stores was a lovely sweet shop and cake decorations could be bought here as well as cards. This shop moved to Cavendish Street and eventually became the Gallery, expanding into artwork as well as craft goods. Woodruff was a well-known dress shop, specialising in bridal wear and wedding outfits. It was a slightly more expensive shop but

very popular, especially for those special occasions. The shops which have replaced many of these come and go and don't seem to have the longevity of the earlier ones.

One local forerunner was Savextra, which was at the bottom of Buccleuch Street behind Rawlinson Street, housed in an old council depot building. It was a 'no frills' arrangement, a 'super discount store' with longer opening hours. This innovation was very popular and provided cheaper food and goods than the small shops. This was followed by other similar stores like Buywrights in Forshaw Street, and led the way to the larger national supermarkets. Forshaw Street and its selection of small shops, pubs and supermarket disappeared beneath the new Portland Walk in the late 1990s.

Very soon Tesco arrived at the top of Dalton Road – right in the middle of the shopping street. In 1974 Asda opened its doors. This revolutionary store was a large employer as well as a retail outlet. It was built on the old industrial land at Hindpool, behind Holker Street, and was modern, with a wide variety of goods, including clothes and had ample parking and, later, a bus service. This was the beginning of a slow decline for traditional shopping and over the intervening years small traders closed and the landscape of the shopping street changed. This heralded the arrival of larger retail outlets appearing on purpose-built retail parks outside the town. Asda was expanded and the impact on the town was huge. Transport links were improved in the early 1990s; the A590 was widened and now avoids Dalton, arriving in Barrow via Park Road. This is an industrial area with many new companies which have been introduced in the latter part of the twentieth century and the start of the twenty-first, such as those at Sowerby Woods Business Park.

Much-needed urban regeneration has been ongoing in Barrow since the 1990s. The new shopping street, Portland Walk, was opened in 1998, which, although it attracted a number of larger retailers like Waterstones, Debenhams, WHSmith and River Island, has not proved to be wholly successful and some units are still unoccupied. Its design drew criticism for its lack of a covered walkway, leaving it open to the elements. The town centre was refurbished but many shops have closed and there is a plethora of charity shops and cheap outlets. Dalton Road, which was the main shopping street, has been pedestrianised and there is car parking close by; however, many of the old shops are closed, with the odd exception, like Marks & Spencer, which has graced the town for many years. It has attracted some popular outlets, such as Costa Coffee and McDonald's.

At the junction of Portland Walk and Dalton Road is the 'Spirit of Barrow' statue, which depicts the skills and workers of Barrow through the ages: a Victorian riveter, a 1950s joiner, a welder and a female electrician, representing the diversity of the workforce today.

TWENTY-FIRST-CENTURY DEVELOPMENT: LOOKING TO THE FUTURE

The one common thread through the industrial history of Barrow is the shipbuilding industry. Shipbuilding was a by-product of the early Victorian industry but soon became a mainstay and has endured through difficult times, becoming the main employer in the area. The shipyard has outlived many of its contemporaries and continues to play an important role in the national defence programme. Throughout its history it has fought for Ministry of Defence contracts and has frequently won. The later chapter included the Trident missile and submarine programme and there has been much debate about whether this should be renewed and continued.

In 2016 Michael Fallon, the then Minister for Defence, visited BAE Systems in Barrow to witness the first metal cut for the Dreadnought programme. Four new submarines will be built for the Royal Navy, replacing the Vanguard class. This will be the next generation of nuclear deterrent submarines and will be in use by 2030. Naturally, this has been a boost for local and wider employment and has assured prosperity for the town once again. A large programme of building has been undertaken and the construction hall rivals the Devonshire Dock Hall in size, presenting another industrial monolith to dominate the landscape. It sits in juxtaposition with the earlier Victorian workshops a physical illustration of how far this industry has come.

One recent construction project has divided opinion in the town. This is the £4-million offshore wind farm and operations centre built in 2005–06. The development is an enormous thirty-turbine, 90-MW capacity, offshore wind farm and dominates the once open view across the Irish Sea. It is operated by Barrow Offshore Wind Ltd and is owned by Dong Energy. The second phase off Walney Island has produced one of the largest offshore wind farms in the world. There is also the West of the Duddon Wind Farm which covers 73 sq. km. This has produced jobs locally and is a boost to the local economy; however, there is resistance to the potential damage to the environment and to the surrounding view. The green lobby salute the development but there are negative aspects, such as damage to local wildlife habitats, seabird colonies, and issues with shipping lanes and fishing. The turbines are not always in use and only provide limited energy depending on the weather. These are not the only turbines – there are a number of large turbines across the moors at Kirkby and on local farms. Love them or hate them, they are here to stay.

More investment in green energy can be seen at Roanhead Farm, a massive solar energy farm built on former agricultural land. This is not the first time the land has been given over to

DDH Trident construction sheds.

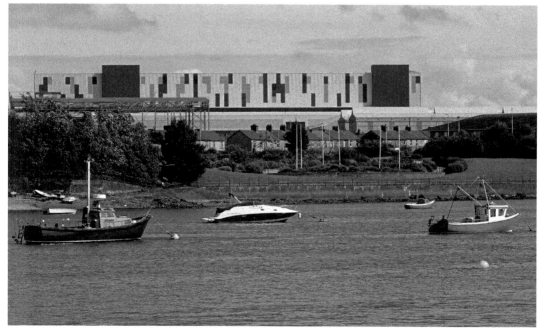

BAE System's new submarine construction hall.

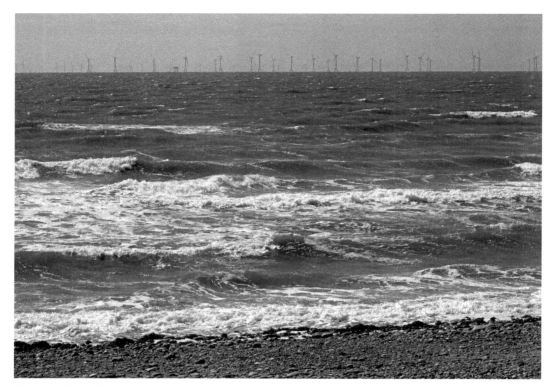

Wind turbines. (Courtesy of S. Patience)

Roanhead Solar Farm. (Courtesy of T. & N. Curtis)

industry. During the nineteenth century the land was used for iron ore mining and evidence is still visible in the landscape. Nigel and Rita Pits are still in evidence but have become part of the natural landscape.

The solar farm covers 37 acres and incorporates 28,382 solar panels. It is sited on three fields and retained within the original hedgerow boundaries. These have been enhanced and replanted as part of the scheme. Kinetica Solar, the company who have created this scheme, have paid special attention to conserving what is already there and work to retain the working environment of the farm. Grazing for animals is still available between the panels, and the environmental and visual impact is minimal because the site is well hidden. This whole scheme was erected in less than a month without changing any major features in the land, and once removed the site will be as it was previously.

Green technology is a positive move forward and marks a slow transition from fossil fuels to green energy. The Roosecote Power Station began as a coal-fired power station in 1954. It provided jobs locally and became part of the Central Electricity Generating Board in 1957. The power station was changed to gas in 1991 and was the first Combined Cycle Gas Turbine power station to generate power into the National Grid. It was decommissioned in 2012 after failing to win a planning application to create a biomass plant. There was huge public opposition to the plan and closure of the existing plant followed. The station was demolished between 2014 and 2015.

Rampside Gas Terminal (or Westfields) connects to the natural gas fields in Morecambe Bay and the Irish Sea. The terminal is next to the site of the demolished Roosecote Power Station. Production began in 1985 and there are three terminals, and Centrica employs more than 400 personnel, both onshore and offshore. The terminal is undergoing change again as one terminal is being demolished to prepare for a new project. The site will become the world's largest battery storage plant and will create another 100 jobs.

Retail in the town has changed immensely and a rash of external retail parks has sprung up on the outskirts of the town – often in place of old industrial sites. Hollywood Park boasts retail outlets, fast-food restaurants and various forms of entertainment. Hindpool, Cornmill and Cornerhouse host a variety of retail outlets, there is a huge Tesco Store which rivals both Asda and Morrisons, as well as a number of smaller Tesco Metro stores dotted around the suburbs. Other large outlets exist on the outskirts such as B&Q, B&M Bargains and Halfords. The reuse of this land for retail is appropriate and provides some commercial continuity for the town.

The town itself has suffered due to the recent economic crisis and some retailers have survived better than others. A lot of shops in the centre remain empty or have given way to charity shops, presenting a poor image for the town. Portland Walk – an uncovered shopping street – has done little to revive the town centre, though a few of the larger retailers do remain, like Debenhams, Thorntons and Waterstones. Principally, however, the retail parks are the biggest providers of goods and employment – flexible and part-time working is available and turnover is rapid. However, the competition is acute and work is not as easy to obtain as in the immediate post-war years.

As well as the retail parks there is a large commercial zone at Channelside, which also houses Furness College – recently expanded and another employer for the town. Commercial offices such as Liberata, Trinity Enterprise Centre and Phoenix Business Centre all sit alongside car dealers, building and plumbing suppliers. An echo of the past is reflected in the street names – Bessemer Way, Ironworks Road and Ashburner Way all recall the halcyon days of the iron and steel works which resided in this area.

The Solar Farm at Roanhead. (Courtesy of T. & N. Curtis)

Entrance to the now defunct Roosecote Power Station.

Pylons and power lines on the site of the former Roosecote Power Station.

Entrance to Westfields Gas Terminal.

Hollywood Park retail outlet was built on former industrial land.

Multinational companies and fast-food outlets grace the site of former industries.

The former Custom House is now a restaurant.

Trinity Business Park.

Liberata offices.

The new Barrow Police Station.

Jubilee Bridge looking towards the Trident sheds. (Courtesy of S. Patience)

Strangely, the fashion today appears to be towards moving services away from the town centre and towards the outskirts; for example, the police station has shifted in this way. In 1967 the police force had become part of the larger Lancashire Constabulary again, and was finally moved to Cumbria Constabulary in 1974 following the boundary changes. The police service has changed over the years and police on the beat are fewer than during the early days. Cars have given way to cycles and of course women are an important part of the workforce now. The police stations have come and gone too – the earlier stations being leased in 1874 in Crellin Street and Rawlinson Street. The Market Street station has recently been abandoned in favour of a new building on St Andrew's Way; a small out-of-town industrial estate. The state-of-the-art building boasts space for 300 employees, eighteen cells, garage and workshop, and its design apparently has 'a sense of place', echoing the shape of a ship and reflecting the history and industry of Barrow. That said, many wonder why in a time of austerity such a costly replacement was necessary.

Barrow is a survivor. It has endured periods of boom and bust, industries rising and falling like the tide. The original industries which triggered the development of the town have gone and left little trace, but the one industry which was born out of the period of innovation and diversification has managed to sustain its growth and continuance, meeting adversity with imagination and embracing change. The shipyard is tied to Barrow and their futures are inextricably linked. The core industry is crucial to Barrow's survival, but new industry comes and goes, blossoming around it. The future looks positive: there are new opportunities with green energy projects, but, as always, the key is the success of the 'yard'. The physical landscape is dominated by the shipyard, its buildings rising ever larger and more imposing, it can't be ignored and it is a reminder of its importance and its influence on the town as a whole. Hopefully the town can survive and will continue to live up to the aspirations of its founders.

ABOUT THE AUTHOR

Author Gill Jepson is passionate about history, particularly that of the Furness peninsula, and is chair of Furness Abbey Fellowship, who work in partnership with English Heritage. *Barrow-in-Furness at Work* is her third publication for Amberley Publishing, following *Barrow-in-Furness Through Time* and *Secret Barrow-in-Furness*. She delivers talks on local history and writes regular articles for the online magazine 'Huddlehub'. She is a Patron of Reading and regularly visits schools. Details of her books can be found at: www.out-of-time.co.uk.